IMAGES
of America

HAWTHORNE

IMAGES
of America

HAWTHORNE

Walt Dixon and Jerry Roberts

ARCADIA

Published by Arcadia Publishing
Charleston SC, Chicago IL, Portsmouth NH, San Francisco CA

Printed in Great Britain

Library of Congress Catalog Card Number: 2005922912

For all general information contact Arcadia Publishing at:
Telephone 843-853-2070
Fax 843-853-0044
E-mail sales@arcadiapublishing.com
For customer service and orders:
Toll-Free 1-888-313-2665

Visit us on the internet at http://www.arcadiapublishing.com

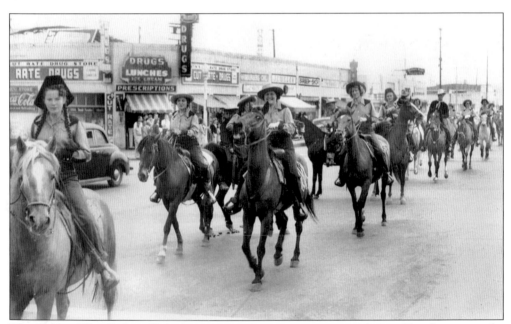

The Golden West Riding Club always enjoyed an opportunity to ride in a Hawthorne parade, which often enjoyed regional attendance and television coverage. In this 1948 photo, club members ride their mounts in front of Mastin's Drug Store at 100 East Broadway.

CONTENTS

ACKNOWLEDGMENTS

People in the city of Hawthorne and a few outside its borders have donated their time, energies, photographs, knowledge, and general goodwill to help see this book through to fruition. The authors would like to thank Hawthorne mayor Larry Guidi, police chief Stephen Port, city clerk Danny Juarez, city manager Richard Prentice, city attorney Glen Shishido, Jag Pathirana of the finance department, councilpersons Ginny Lambert, Pablo Catano, and Louis Velez, as well as Larry Bender, Julie Cruz, Irene Greasby, Beth Hartzell, Robert Hartzell, Nicole Houston, Annazell Joseph, Fred Koeller, Thierry Lubenec, Monica McClanahan, Lisa Miller, James Osborne, Tom Quintana, Jan Vogel, Tom White, and Mickey Winters.

FOREWORD

As mayor of Hawthorne for more than a decade and a member of the city council for years prior to that, I can state with conviction that Hawthorne truly is a city of good neighbors. But Hawthorne is much more than that: it is a city with a fascinating history.

Some of our country's most famous celebrities lived in Hawthorne. Among the most notable was the great Jim Thorpe, a legendary Olympian and professional baseball and football player. Marilyn Monroe, one of the most famous movie stars in the world, also lived in Hawthorne as a girl. And The Beach Boys, one of the most famous rock 'n' roll bands in history, got their start here while attending Hawthorne High School. Hawthorne is also one of the cradles of the United States aerospace industry. Founded by Jack Northrop in 1939, the Northrop Company is now the global defense giant known as Northrop Grumman Corporation.

Yes, Hawthorne enjoys a colorful history filled with pop icons and places to visit that you will become more familiar with after digesting this outstanding book. From the days of the Pacific Electric Red Car, to the legendary meetings at the Cockatoo Inn, to Hawthorne's new state-of-the-art police station, Hawthorne has been and continues to be an exciting place to visit and live in. And it always manages to maintain its small-town charm.

It has been an honor and a privilege to serve the residents of this fine city for so many years. I extend my warmest congratulations to Mr. Walt Dixon for putting together this extraordinary work of art. I am positive that it will be a staple of our community for many years to come.

—Larry Guidi
Mayor of Hawthorne, 1992–present

INTRODUCTION

The prehistory of Hawthorne, California, follows that of many South Bay cities in southwestern Los Angeles County. According to archaeologists, the original people in this area descended from a group of ancient hunters who migrated across the Bering Strait as early as 10,000 years ago. Sometime prior to 2000 B.C., the Uto-Aztecan (Shosonian) group, known today as the Gabrielino tribe, began to inhabit the area.

In 1542, Juan Cabrillo, a Portuguese captain sailing under the Spanish flag, was believed to be the first European to explore California's coastline. The first land expedition was made under the command of Gaspar de Portola. In 1769, upper and lower California came under the control of the King of Spain. By 1784, the granting of the lands for ranchos in the Los Angeles area had begun. When Mexican independence was finally achieved in 1822, some 30 rancho concessions had been distributed. One of those early Mexican land grants was the Sausal Redondo, or "Round Clump of Willows." It was received in 1822 by Antonio Ygnacio Avila as a provisional grant by Captain Jose Arrega, the commandant of Santa Barbara.

Sausal Redondo was comprised of the present cities of Hawthorne, Inglewood, Lawndale, El Segundo, Manhattan Beach, Hermosa Beach, and portions of Redondo Beach and Playa del Rey. A decades-long land dispute over the Sausal Redondo continued after the land changed nations again. The 1848 Treaty of Guadalupe Hidalgo ceded upper California to the United States of America. Two years later, the state of California was admitted to the union. Avila was eventually acknowledged as the legal landholder after the district court ruled in his favor in 1856.

After Avila died in 1858, his heirs sold the land containing today's Hawthorne to Scotsman Sir Robert Burnett. Burnett abandoned his American ranching venture inside a decade and leased the Sausal Redondo to eclectic Canadian developer Daniel Freeman, whose story is more closely aligned to the city of Inglewood's. After 12 years of leasing and hardships, including drought, Freeman completed a final purchase of the land from Burnett for $140,000.

In 1887, investors from Los Angeles, Pasadena, and Monrovia organized several companies whose successes were dependent on railroads that then spread from Los Angeles. These companies sought to buy large chunks of acreage from Freeman. The purpose was to lay out plans for towns in the countryside near Los Angeles. One such company was the Hawthorne Improvement Company.

One
BEGINNINGS

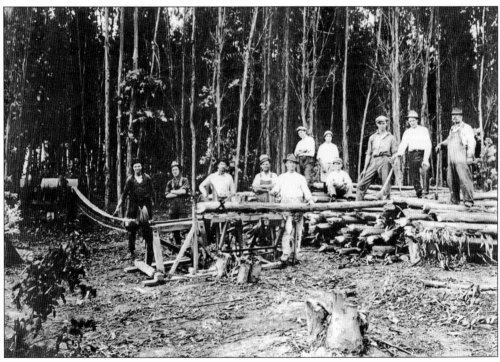

The area that became Hawthorne contained thick forests of previously planted eucalyptus trees. This 1909 lumber camp was located at the site of what became Hawthorne Hospital at 117th Street and Grevillea Avenue.

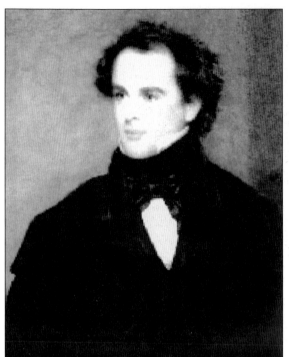

Nathaniel Hawthorne (at left in this reproduction of a painting) was the famous New England author of the novels *The Scarlet Letter* (1850) and *The House of the Seven Gables* (1851). His books of short stories included *Twice-Told Tales* (1837). He died in 1864, 41 years before the founding of his namesake city in California. Hawthorne was founded by B.L. Harding and H.D. Lombard in 1905 as the Hawthorne Improvement Company. Harding's daughter, Mrs. Laurine H. Woolwine, shared the novelist's birthday—Independence Day—and chose to name the city after him.

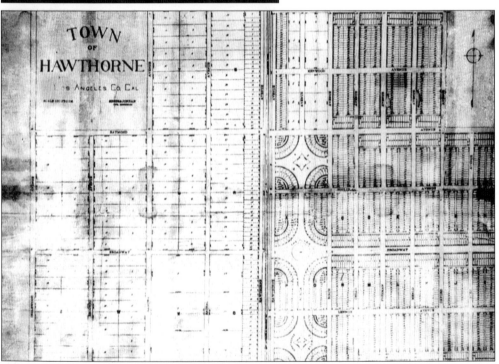

This is the original layout of the envisioned "Town of Hawthorne" as it was chartered in 1906 by the Hawthorne Improvement Company. The city is centrally located in the South Bay section of Los Angeles County, about 14 miles south/southwest of downtown Los Angeles and about 14 miles northwest of downtown Long Beach.

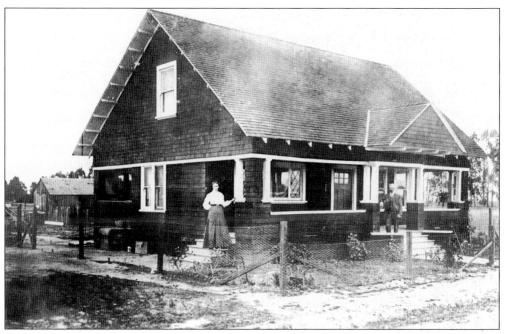

Built in 1906 or 1907, the Wren family house, located at 12519 Oxford, was one of the first company houses in Hawthorne.

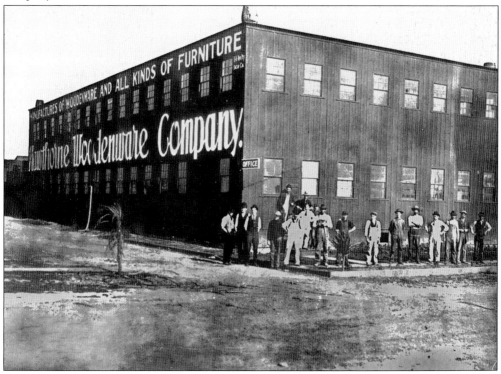

The Hawthorne Woodenware Factory was located on Raymond Street, now known as 120th Street, just east of Hawthorne Boulevard. The factory made chairs, tables, and other furniture. Furniture-making gave Hawthorne its first identity as a manufacturer.

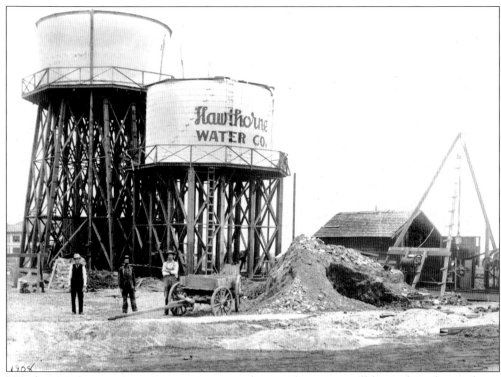

Hawthorne's first water company was a privately owned artesian well located on the southeast corner of Hawthorne Boulevard and Ballona Street (which became El Segundo Boulevard). In this 1908 photo, a portion of the old Ballona School can be seen behind the tower supports on the left.

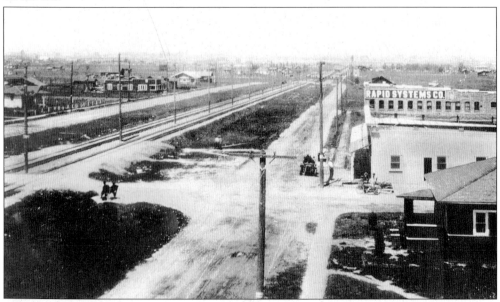

Always a vast thoroughfare because of its development out of the right-of-way for the Los Angeles and Redondo Electric Railway, Hawthorne Boulevard is shown looking north from Raymond Street (which later became 120th Street) in this 1910 photo.

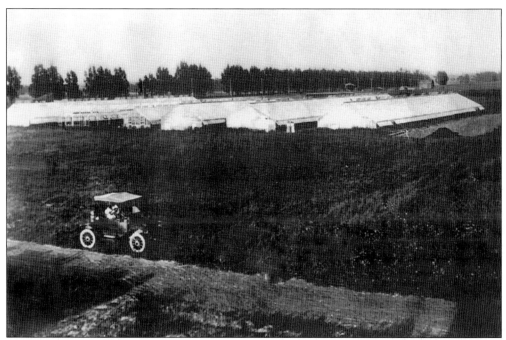

This photo depicts the Satow floral farm on Kornblum Avenue in 1915. The agrarian expertise of Japanese immigrant farmers produced a wide variety of truck-farm crops in the South Bay for more than a generation—or before Japanese Americans were forced into concentration camps during World War II. Mr. Satow is pictured at the wheel of his new Model T Ford.

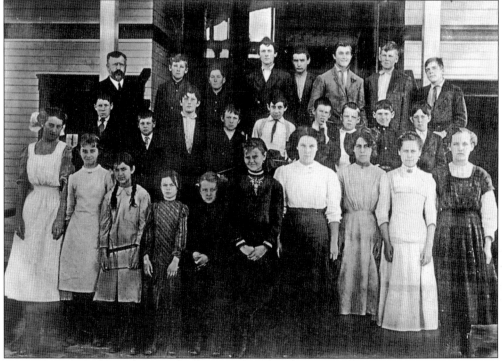

Shown here in 1909 is the entire Hawthorne Grammar School class.

There's a New Jewel in the Crown of Southern California

The Beautiful New Town of

HAWTHORNE

Between Los Angeles and the sea, on the way to Redondo. The most pleasing subdivision ever platted around Los Angeles. Broad streets. An extensive plaza planted to ornamental shrubs. A stately circular roadway skirting the plaza. Cement curbs and walks. Water piped to lots. Ornamental gateways spanning the entrances. A model city in every way and destined to take precedence at once over every other suburb of Los Angeles. Over 400 lots sold on the opening day, Sunday, January 7th, indicating the favor with which the public welcomed the new town. Many new buildings already under way. A special offer of a lot free to the first ten purchasers erecting houses costing not less than $750 each.

LOTS $75 UP

A good opportunity for parties looking for safe and profitable investment to participate in the steady advance of Los Angeles and surrounding country.

CALL OR WRITE FOR MAP AND CIRCULAR

Golden State Realty Co.

Founders of Watts and Builders of Southern California towns
Largest Realty Company in the State
Paid-up capital and surplus over one-half million dollars

421 South Spring Street . Both Phones Exchange 56

This Golden State Realty Company newspaper advertisement appeared on January 6, 1906. The ad asserts that "the new town of Hawthorne is the most beautiful suburban town ever plotted in this section." A lot could be had for $75 with a $1 down payment and a mortgage of $1 per month.

14

A front-page flyer was distributed in 1906 by the Hawthorne Land Company showing the prices for lots in the area. The mortgage listed on this flyer was $3 a month with "no interest—no taxes." The vertical description extols "A Chicken Yard near Hawthorne."

PRICES OF LOTS RANGE FROM

$85 to $360

TERMS: 10% Cash, Balance $5.00 per Month

NO INTEREST--NO TAXES

These prices and terms enable a man or woman of moderate means to procure a home or profitable investment.

A Chicken Yard near Hawthorne.

Another advertisement boasted "The New Town" of "handsome" Hawthorne, California.

The first and only blacksmith shop in Hawthorne, owned by the Velarde family, was located at the corner of Kenwood Street (eventually 119th Street) and Birch Avenue. This 1911 view, facing Birch, also shows the Velarde home before a fire destroyed it.

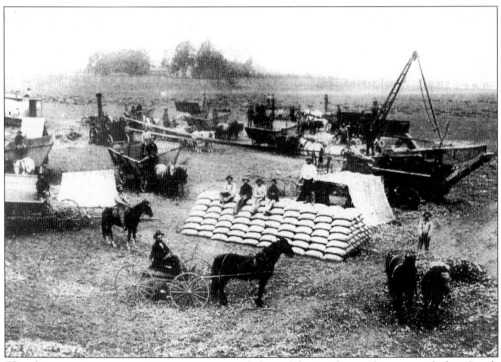

Threshing grains was an important part of farm life in the early years of the South Bay's agricultural history. It was an enormous annual undertaking, as this photo from around 1916 illustrates.

This adobe, shown in 1908, was built by the Baldo children and was surrounded by a garden patch. Among the children shown are Anita, Ameriga, and Italo, who are with their cousin Clare Maria.

Two of the earliest families living in Hawthorne were the Sheligas and the Baldos. Among those depicted in this 1908 photo are Agnes, Frank, and Joe Sheliga, and the Baldo children, Anita, Ameriga, and Italo.

Hawthorne's first fire truck was this ladder-and-hose rig. The volunteer firemen appeared pleased with their then very modern 1912 conveyance.

GRADUATES

Paul Oviatt Roest,
Byron B. Bott,
Daniel Emmerson Wiltse,
Eleanor Dorothea Southstone,
Cecil E. Mullins,
Angelina Rose Pece,
Mary Elizabeth Johnson.
Arthur Leslie H. England,
Mary Sustarich
Frank L. Augustus
William Pierson Jones

Claude A. Porter,
Vera Anna Lory,
Loyd C. Wooley,
Harold Chanslor,
Mildred Marie Grannis,
Beatrice Orelma Wheeler,
Albert Farris Cummins,
Marie Mina Schleuter,
Flossie D. Wooley
William Thomas Heisler
George Martin Timmons

Nobuki Yania

The graduating senior class from Hawthorne Grammar School is pictured and listed by name.

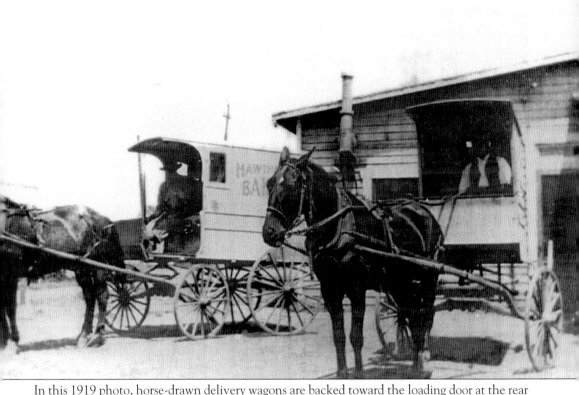

In this 1919 photo, horse-drawn delivery wagons are backed toward the loading door at the rear of the Becker-family-owned Hawthorne Bakery.

World War I inspired many communities to muster a sense of paramilitary preparedness. Here, the Hawthorne Home Guard drills at its Ingledale Club site.

Two

GROWTH IN THE 1920S

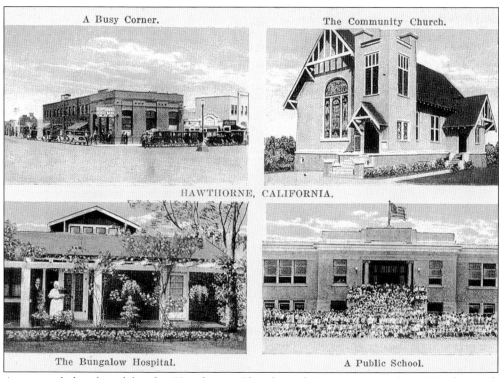

A postcard distributed by the Hawthorne Chamber of Commerce in the 1920s depicted, clockwise from upper left, a busy corner, community church, public school, and "The Bungalow Hospital" or Cottage Hospital.

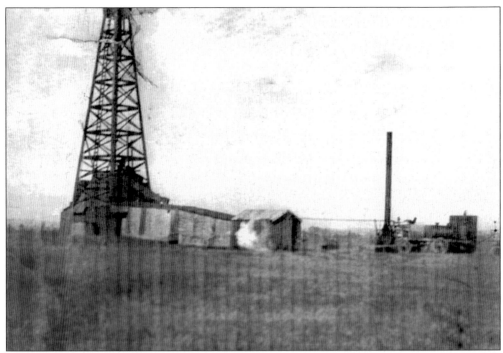

This was the very first oil-drilling rig in the Hawthorne area, located on the Leuzinger Ranch just off Rosecrans Avenue. The well was brought in by Joe Dean Dixon in 1924 and was the first paraffin-based oil well on the West Coast. All the rest of the West Coast wells at that time yielded sulfur-based oil.

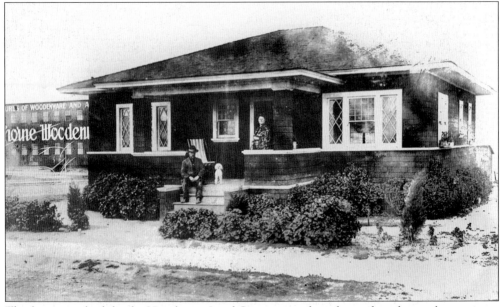

This house was built by the Hawthorne Land Company and was located on the southeast corner of Hawthorne Boulevard and Raymond Street (later changed to 120th Street). It was purchased from the original owner by Mr. Gus Schlimmer, who moved the house to Birch Street. Schlimmer then built a hardware store on the Hawthorne/Raymond corner.

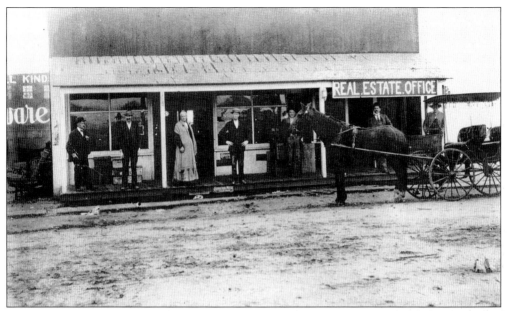

One of the first businesses that became a center of commerce in Hawthorne was the multi-faceted M.B. Garton Real Estate Office, shown here in 1922. It was located near the southwest corner of Broadway and Hawthorne Boulevard. The horse and surrey were used to show prospective buyers the lots for sale.

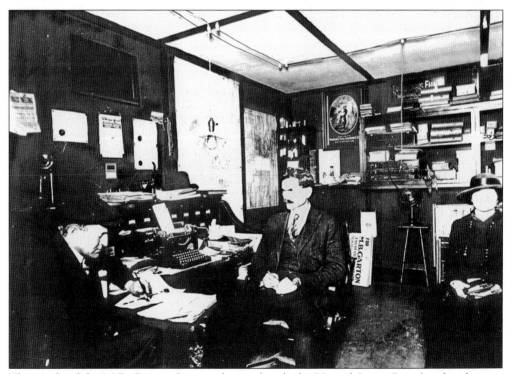

The inside of the M.B. Garton Store is depicted with the United States Postal and real estate offices. Residents picked up their mail from the wall boxes seen in the background.

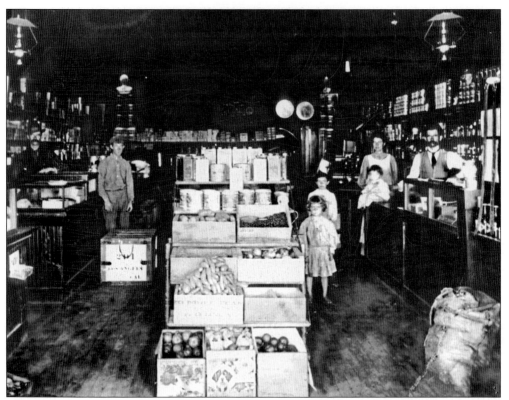

This is another interior view of the M.B. Garton Store. Note the coffee grinder and large oil lamps hanging from the ceiling. The store also had a large wooden pickle barrel.

The M.B. Garton home is seen in 1922 at the southwest corner of Hawthorne Boulevard and Raymond Street, now 120th Street. The Gartons ran a grocery store and had real estate interests in the city.

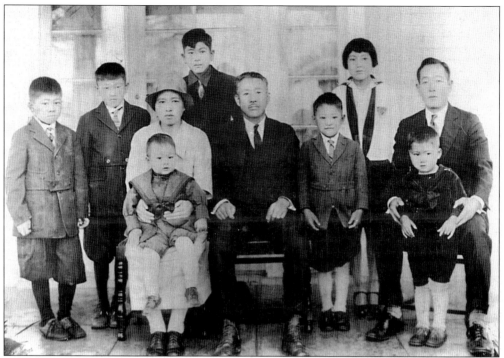

This portrait of the Satow family was taken in 1928. Pictured, from left to right, are: (front row) Tom, mother Shiku with baby Seteuo, father Tomijiro, Tadao, Mrs. Watanabe (a friend), and William; (back row) Henry, Hideo, and Toshiko.

The quaint wood-frame Ingledale home of Delia Rasmussen Velarde was surrounded in the 1920s by a variety of flowers and ornamental plants.

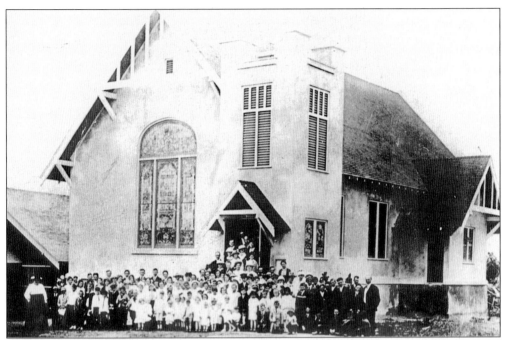

Union Congregation Church on Acacia Avenue, just north of Broadway, eventually became the Acacia Baptist Church. The building to the left was used as a first-grade school and for community meetings.

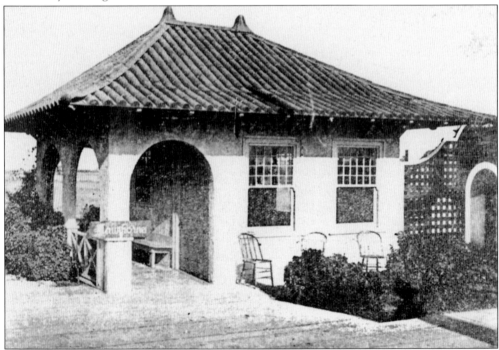

In the 1920s, the Mission Depot was located in the middle of Hawthorne Boulevard at the railroad tracks between Broadway and 126th Street. Steam trains to Redondo Beach and El Segundo stopped here, as did the Pacific Red Car Line and the Yellow Car to Los Angeles.

Hawthorne's first barbershop, seen here in the 1920s, was located on Broadway just west of Hawthorne Boulevard where the police station now stands.

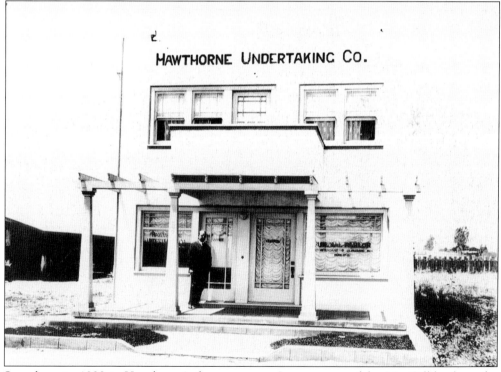

HAWTHORNE UNDERTAKING CO.

Seen here in 1922 is Hawthorne's first mortuary. It was operated by Mr. Gilliland on the present site of the Bank of America parking lot, a few feet south of the railroad tracks.

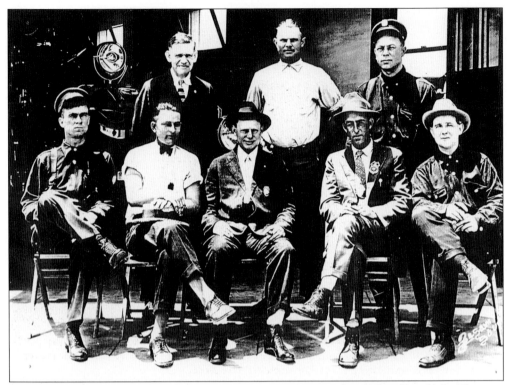

The men of the Hawthorne Volunteer Fire Department came from all walks of life. They are seen here in 1924.

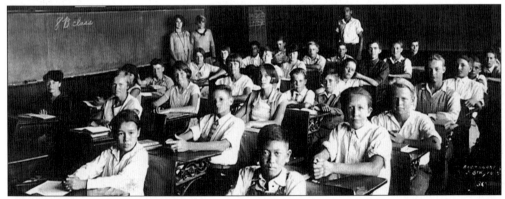

Miss Sherwood's 1927 eighth-grade class at the Ballona School is very attentive to the camera. Hideo Satow is pictured in the center of the front row. The Satow family was one of the notable farming families in Hawthorne.

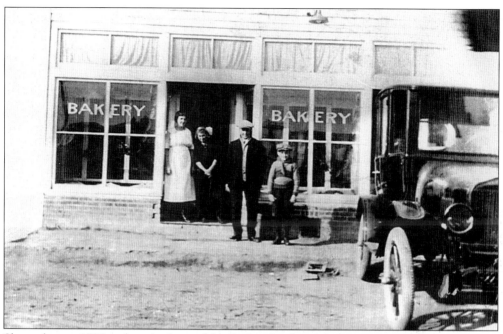

Shown here *c.* 1925 is the storefront of the Becker family market on Acacia Avenue, just south of Broadway. Art Becker and his family operated the general store, which was a bakery, meat market, drug store, and general merchandise/hardware store.

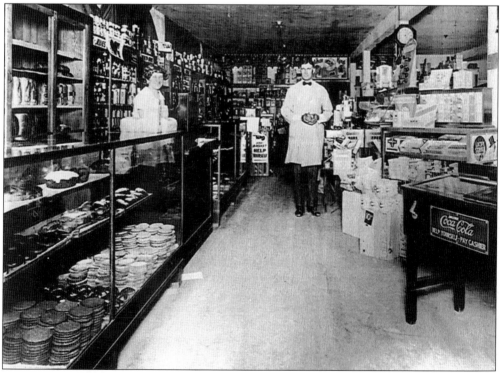

The interior of the Art Becker family market is shown here in the mid-1920s, with baked goods in the glass counter to the left, Coca-Cola to the right.

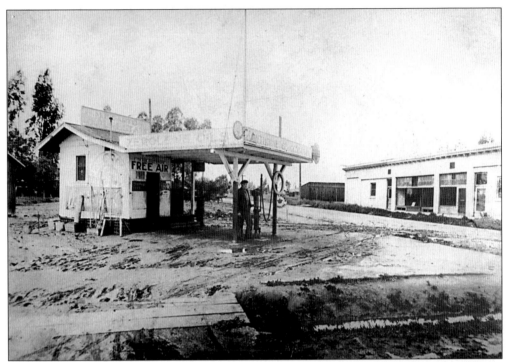

This was the first filling station in Hawthorne. Located at the southwest corner of Hawthorne Boulevard and Broadway, this spot was the terminus of the Los Angeles Railway Line—Yellow Car or LARY Carline. Faded and barely readable signs on the station advertise "Zerolene Oils" (this side of roof), "M.B. Garton Real Estate" (on rooftop), and "Hawthorne Cycles" (in front).

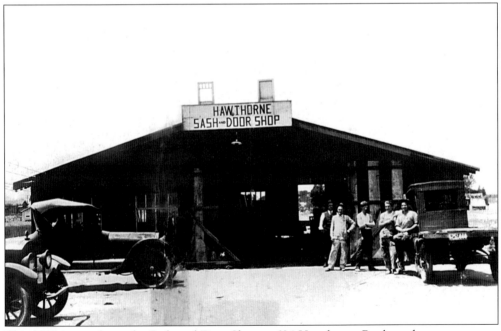

This 1922 image shows the Sash and Door Shop at 624 Hawthorne Boulevard.

The Roush family home is shown here during the 1920s at 4129 West 120th Street.

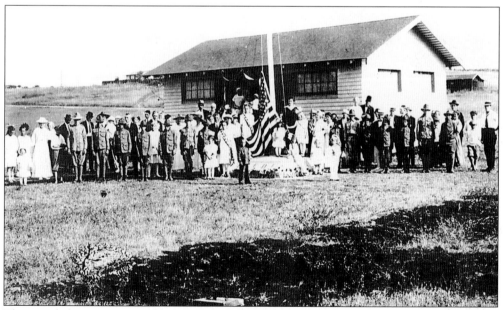

This is a dedication, or possibly a Fourth of July celebration, in the 1920s at the clubhouse on the grounds of Ingledale Acres, near Inglewood Avenue between 131st and 132nd Streets.

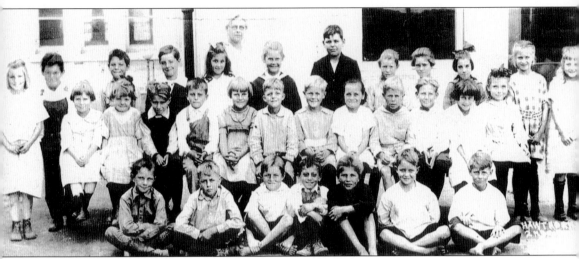

This class photo shows the second grade at Hawthorne Grammar School on November 29, 1921.

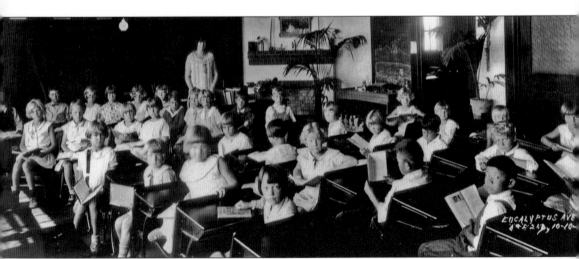

These second-grade students at Eucalyptus Avenue Grammar School seem intrigued by the camera at the back of the room. Among the students in this October 10, 1928 photo are Miss Dornford's class are Gordon Boyer, Inez Franks, Betty Brennan, Thelma Shylock, Irene Smith, Dorothy Hamm, Edward Buckley, and Mildred Hancock.

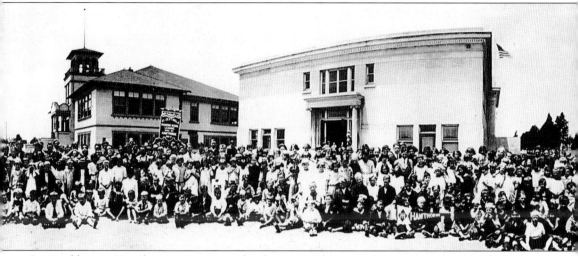

Pictured here is Hawthorne Grammar School, now Washington Elementary School, with all of its pupils posed in front. This photo was taken in the years prior to the 1933 Long Beach earthquake, which so fractured the structure that it had to be rebuilt.

These eighth-graders at Hawthorne Grammar School looked into the eye of photo technology on September 28, 1928.

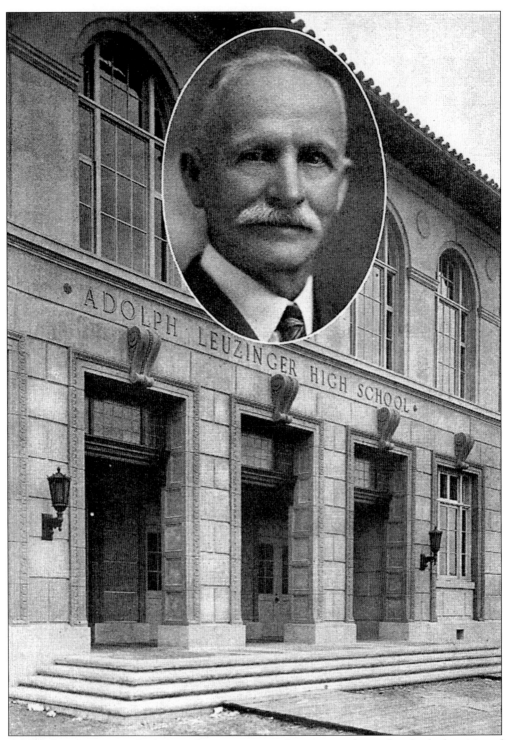

Adolph Leuzinger owned a big ranch on properties that are now located in both the cities of Hawthorne and El Segundo. He donated the land for Leuzinger High School in Lawndale, which was named to commemorate his service to the Inglewood (Centinela) School District.

This postman is depicted in Hawthorne's first United States post office used solely for that purpose, on Hawthorne Boulevard just south of El Segundo. The town's original post office had been in the real estate office of M.B. Garton.

While schoolbusing is often thought of as a post–World War II trend, Wiseburn School (which became Dana School) operated its own bus in the early 1920s, picking up children throughout the town and countryside.

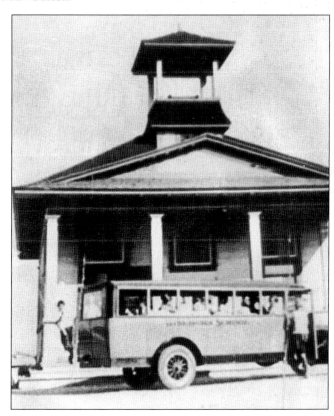

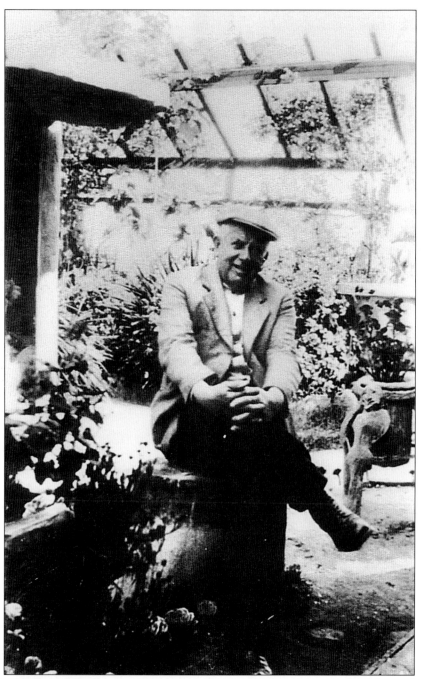

In this 1929 photo, Felix Peano relaxes on the patio of his Hawthorne "villa," his garden residence at 260 Freeman Avenue. Peano, one of the mid-century's foremost artists working in undercut copper, designed and hammered copper doors, each one called a "door of life." His studio was located at 484 North Hawthorne Boulevard. Peano, who worked in ceramics as well as metals and was an expert in architectural ornamentation, designed 12 of the bridges spanning the Venice, California canals. A confidante of novelist Jack London, Peano was born in 1864 in Parma, Italy, and died in 1948 in Hawthorne.

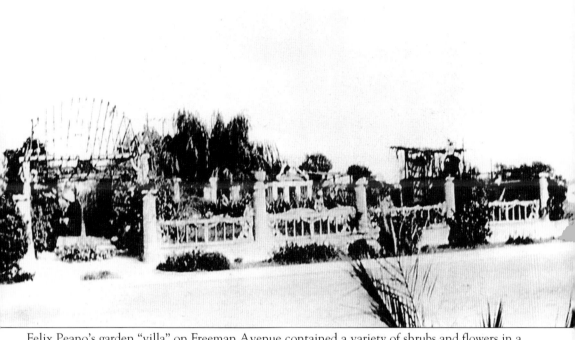

Felix Peano's garden "villa" on Freeman Avenue contained a variety of shrubs and flowers in a mingling of Mediterranean and Southern California styles. A prominent artist during the early 20th century, Peano remains obscured by history. Ella Cole's study of the artist and his achievements remains with the City of Hawthorne archives.

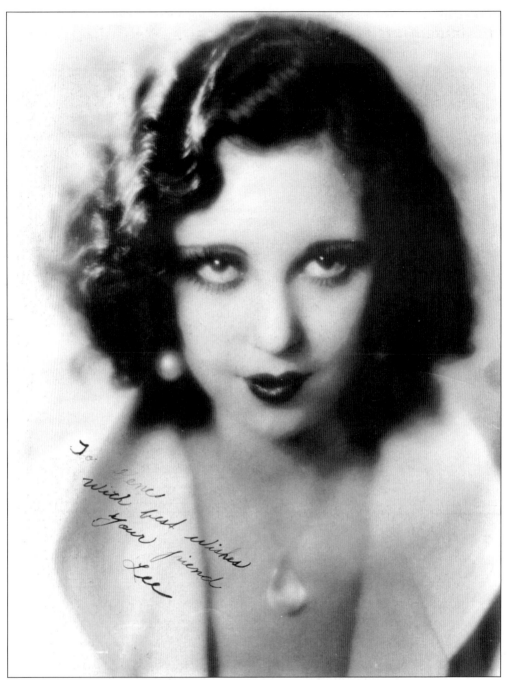

Lee Auburn, seen here in a publicity still, was one of the many Hollywood performers and filmmakers whose lives wended through Hawthorne. She played a chorine in *Bottoms Up* (1934) with Spencer Tracy and also starred in the Educational Pictures, Inc. production of *Loose Relations* (1933). Among other city residents was Vola Vale, a silent-era actress who starred opposite sagebrush stars William S. Hart and Harry Carey three times apiece. Vale died in Hawthorne in 1970.

Prominent Members of the Hawthorne Police Department

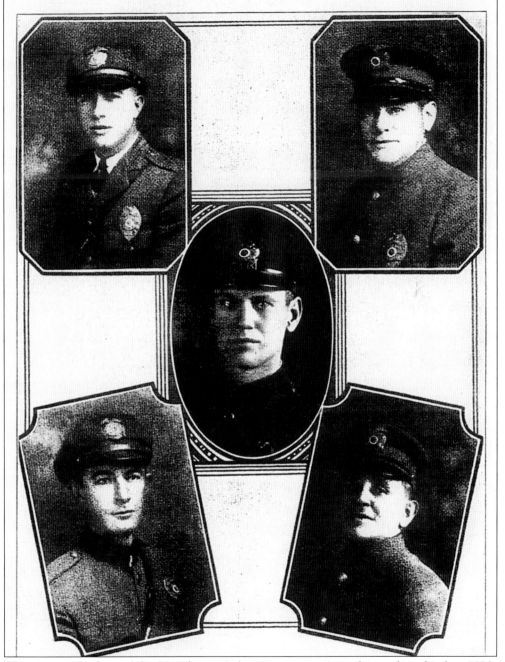

"Prominent Members of the Hawthorne Police Department" are depicted in this late-1920s collage. Tommy Cummings, shown at top left, served on the force for 42 years. In the center is William T. Deal and clockwise from the top right are William Schweitzer, George Davis, and Ray C. Honeywell.

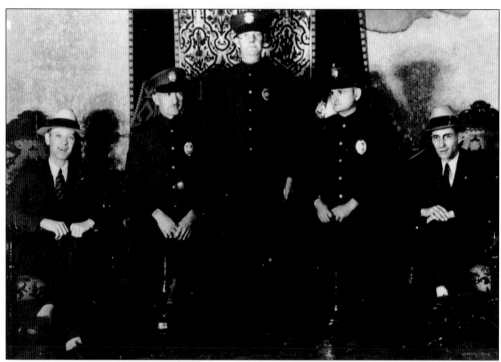

Members of the Hawthorne Police Department are pictured in 1928. From left to right are an unidentified man, Bill Deal, Vern Craig, B. Robertson, and councilman Joe Mackey.

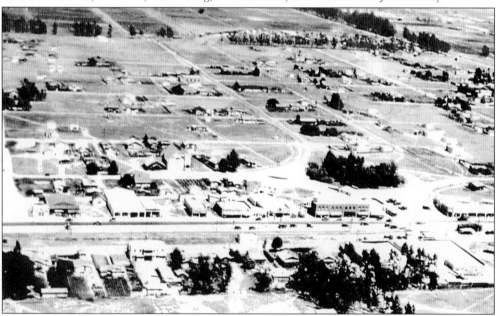

This aerial view of Hawthorne was taken above the present site of Hawthorne High School, looking east across Hawthorne Boulevard. Just below the plaza, at Hawthorne Boulevard and Broadway, are the Reynolds Building and the Mastin Building. At the top of the photo, note the big eucalyptus trees along El Segundo Boulevard and Prairie Avenue. The open space bounded by them became Northrop Aircraft Company and Hawthorne Airport.

Three
DEPRESSION-ERA 1930S

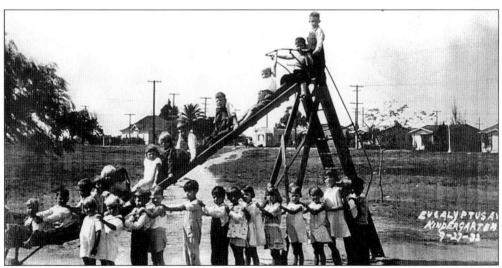

Eucalyptus School's kindergarten class posed for this photograph on September 27, 1932. The school still stands on Eucalyptus Street between Broadway and 120th Street.

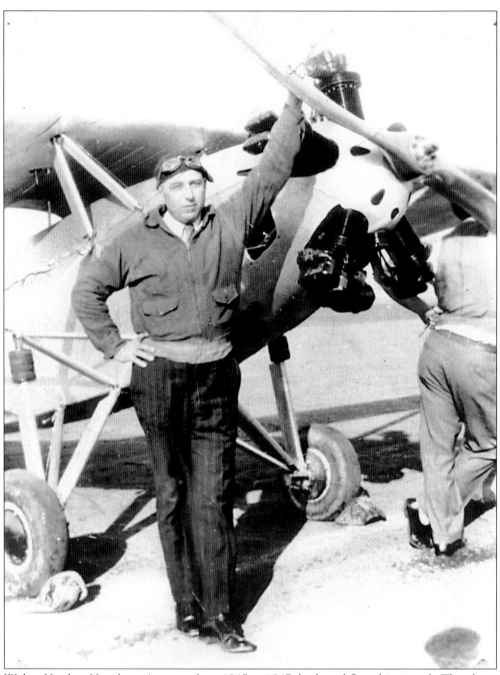

Walter Hawley, Hawthorne's mayor from 1945 to 1947, built and flew this aircraft. The photo was taken in the early 1930s at Kelly Field, which was located at Inglewood Avenue and Broadway. Hawley's daughter, Pat Hawley, later married another Hawthorne mayor, Glenn Anderson, who went on to become lieutenant governor of California under Gov. Edmund "Pat" Brown.

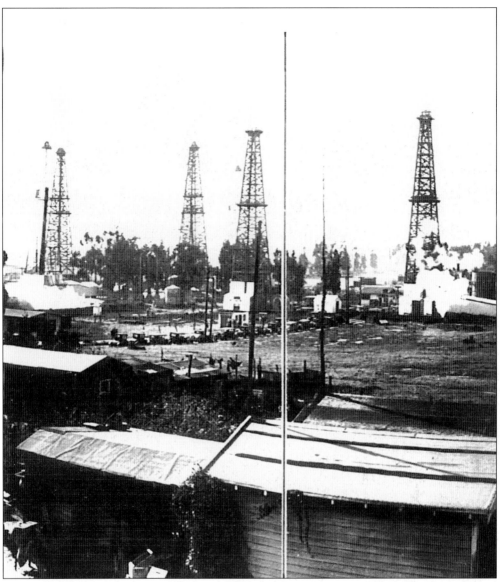

This view, looking northwest from just south of Rosecrans Avenue, illustrates the many oil wells that sprang up in this region in the 1930s.

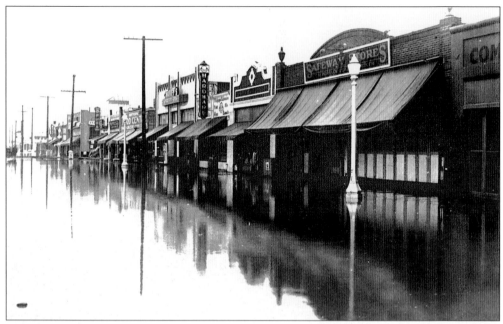

Looking southwest on Hawthorne Boulevard, this vantage point is located just north of Broadway in the late 1930s. Prior to proper storm drains in the 1920s, 1930s, and 1940s, heavy rains often swamped the city's streets.

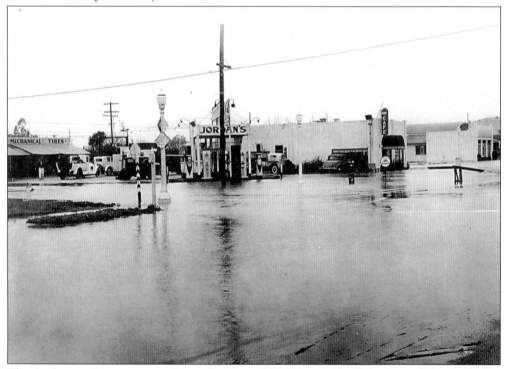

This is the northwest corner of Hawthorne and El Segundo Boulevards in the early 1930s. Jordan's Service Station was a hub of activity in the 1930s and 1940s—except when it rained like this.

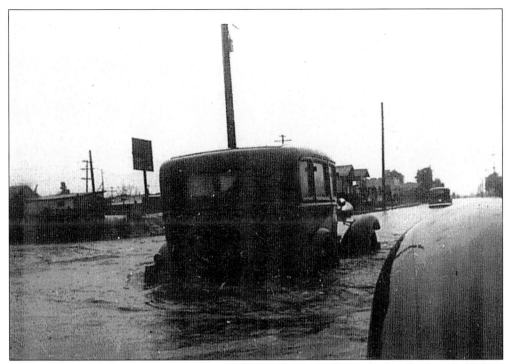

This 1929 Model A Ford traverses one of the streets west of Hawthorne Boulevard. Winter rains were always a hazard in relatively flat areas like Hawthorne.

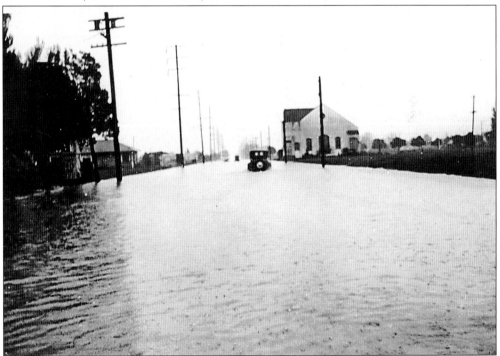

Traveling south on Prairie Avenue, seen here from 137th Street, seemed to require a rowboat on stormy winter days.

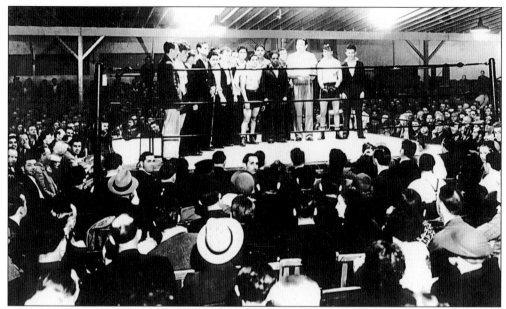

The 1934 heavyweight boxing champion of the world, Max Baer, is shown refereeing a bout at the Hawthorne Club in 1936. The club also was frequented by legendary sportsman Jim Thorpe. Previous to his reign, Baer costarred with Myrna Loy in *The Prizefighter and the Lady* (1933), and he later acted in other Hollywood movies. His son, Max Baer Jr., played Jethro on television's *The Beverly Hillbillies*.

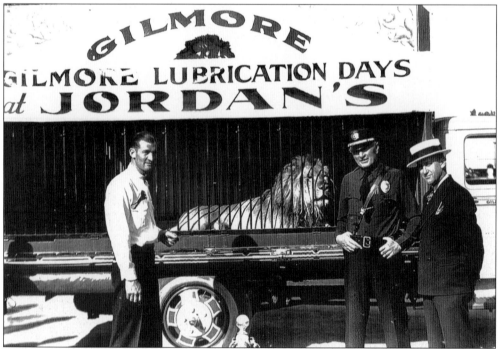

This big cat is the Gilmore Lion, which was taken to filling stations around the region to advertise Gilmore Gasoline. In this mid-1930s photo, the lion visits Jordan's Gas Station at Hawthorne Boulevard and 129th Street.

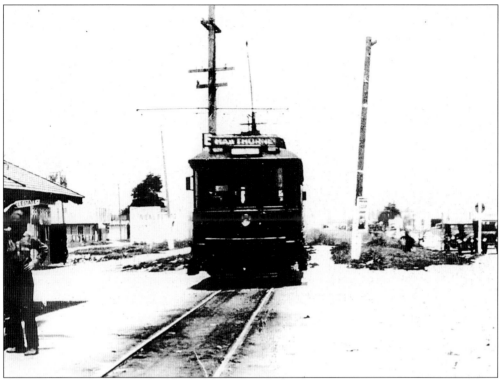

The "Big Red Car" traveled from Broadway and Hawthorne Boulevard and south to Redondo Beach, San Pedro, Long Beach, Norwalk, and back to Hawthorne. The fee to ride it in the 1920s was 5¢, and the speed was 60 miles per hour.

This shot looks north on Hawthorne Boulevard from the Broadway intersection. Note the "Five" Car Line by the poles. The building by the tracks is the Sinclair-Reo Gas Station.

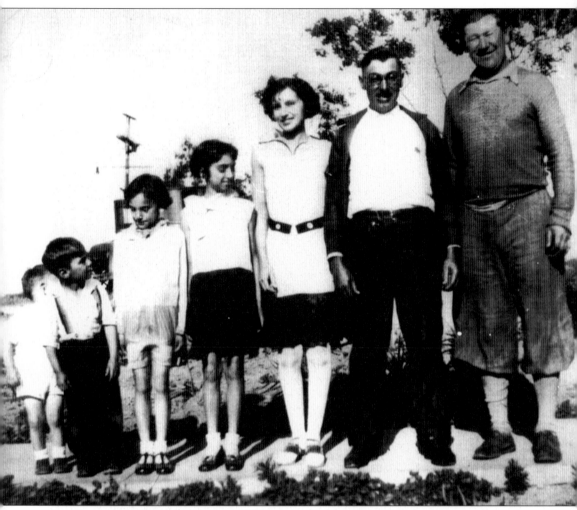

Jim Thorpe and his family posed for this shot in the late 1920s. Jim lived in Hawthorne for at least two decades. During the 1930s, his wife Freeda, pictured, worked in the City of Hawthorne's finance department. Thorpe died of a heart attack in a trailer home in South Bay, in nearby Lomita, on March 28, 1953. The City of Hawthorne ensured that his name would live on in the community with the Jim Thorpe Park at 139th Street and Prairie Avenue. Thorpe was a very personable neighbor who frequented the Centinela Cafe and used to bowl at the Hawthorne Club. "Other times we went bowling in Hawthorne, California, and he threw a powerful ball," his daughter told biographer Robert Wheeler about nights at the Hawthorne Club. "It didn't matter what side of the headpin he hit because they all would go down and he'd have another 200 game."

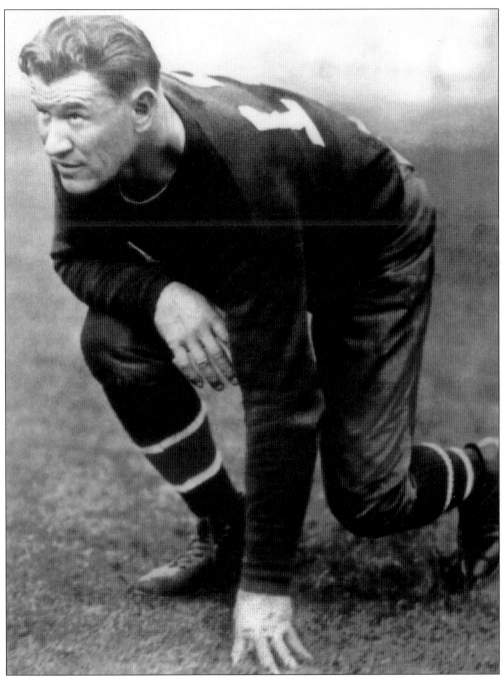

Jim Thorpe is pictured here in the 1920s. He was an All-American football player at Carlisle College in Pennsylvania and a pro football Hall of Famer. In the fledgling National Football League, he played with the Canton/Cleveland Bulldogs, Oorang Indians, Rock Island Independents, New York Giants, and Chicago Cardinals during the 1920s. A tavern regular around Hawthorne in his later years, Thorpe also played bit parts in Hollywood B movies, served in the Merchant Marines during World War II, and dabbled in his native Sac and Fox tribal politics.

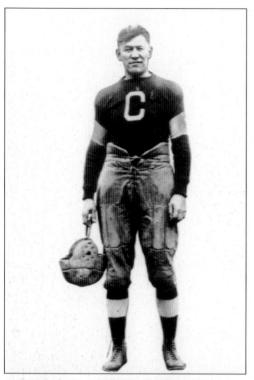

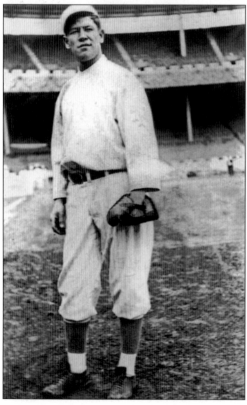

Thorpe won gold medals in the pentathlon and decathlon in the 1912 Olympic Games in Stockholm, Sweden. His Olympic medals were infamously taken away from him after it was learned that he had been paid to play semipro baseball prior to Stockholm and therefore wasn't a true amateur. The medals were restored to his heirs many years after his death—even though today many pro athletes play in the Olympics. As a baseball outfielder, he played for six seasons with the New York Giants, Cincinnati Reds, and Boston Braves. In 1950, an Associated Press poll of sportswriters named Thorpe the outstanding male athlete and best football player of the first half of the 20th century.

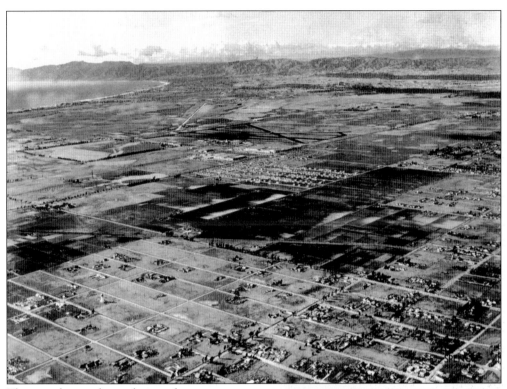

This aerial view shows the area between Rosecrans Avenue and 120th Street looking northwest. The arc of Santa Monica Bay and the Santa Monica Mountains can be seen in the upper left portion of the photo and the Los Angeles Basin is at the top center. The east-west street with the barely noticeable trees in the center is 120th Street. Note the open land west of Inglewood Avenue.

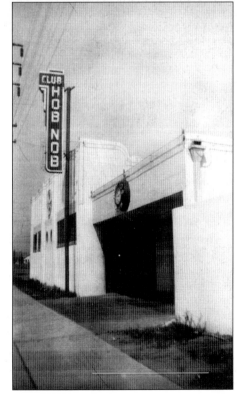

Club Hob Nob on Prairie Avenue was one of several legal gambling houses that proliferated in Hawthorne in the 1930s. This site was later occupied by the Prairie Vista School.

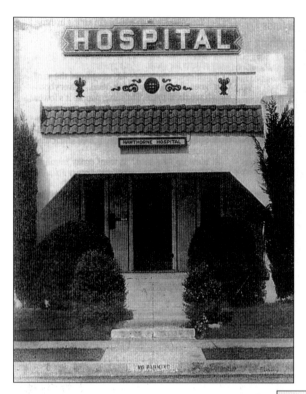

Pictured here in the 1930s is Hawthorne Hospital, which was known as the Cottage Hospital during the previous decade. Located on South Grevillea Avenue, it was later known as the Robert F. Kennedy Medical Center.

HAWTHORNE HOSPITAL

711 GREVILLEA AVENUE
HAWTHORNE CALIFORNIA
PHONE: HAWTHORNE 23

SCHEDULE OF RATES

4-bed ward, per day	$ 3.50
2-bed ward, per day	4.00
Private room, per day	5.00

Above prices include board and general care only.

MATERNITY RATES

4-bed ward	$35.00
2-bed ward	45.00
Private room	55.00

This is ten-day rate to include everything for normal delivery. Hospital furnishes all nursery clothes during stay.

SURGERY RATES

Minor	$5.00 to $10.00
Major	$15.00 to $25.00
Tonsillectomy (with 24 hours care)	12.50
D and C (with 24 hours care)	12.50
Obstetrical Cases (with 24 hours care)	12.50

HAWTHORNE HOSPITAL
711 GREVILLEA AVE
HAWTHORNE CALIFORNIA phone 23

The Hawthorne Hospital rates schedule in 1936 included major surgery for between $15 and $25. A private room was $5 per day. All you had to do was call 23—the hospital's local telephone number.

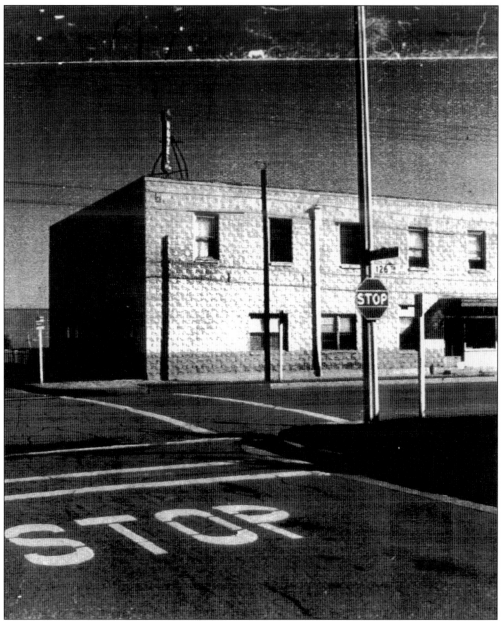

This modest-looking building was once the Hawthorne Hotel. While this is a 1950s-era photo, the building appears in much the same way as it did in 1936 when it was the setting for a significant moment in aviation-business history. Inside the third window from the left (above the stop sign) John K. "Jack" Northrop and his business partners met and germinated the idea for Northrop Aircraft Company. After several years of constructing buildings as well as the Hawthorne Airport in the northeast corner of the city, they began producing airplanes. Northrop Grumman Corporation still operates at 1 Northrop Avenue, Hawthorne.

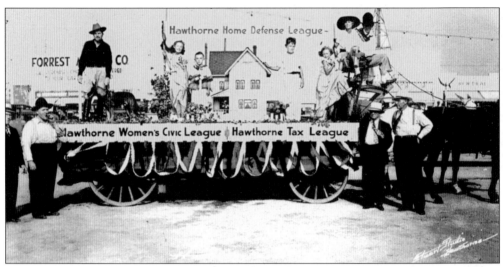

This photo from the 1937 Pow Wow Days was taken on Hawthorne Boulevard a few blocks south of El Segundo Boulevard. Standing on the pavement, from left to right, are an unidentified city councilman, the familiar visage of John Kaplis Sr. with his black hat and cigar, mayor William Reese, and another unidentified official. On the wagon with the dog is Frank Kaplis.

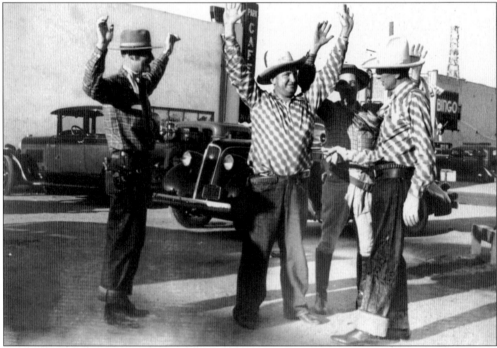

Members of the Hawthorne Police Department ham it up in preparation for Pow Wow Days in 1936. Pow Wow Days was a huge, annual citywide celebration during the 1930s involving city officials, social clubs, and community groups. The theme was the Old West, and parents and children alike played cowboys and Indians. Men carried sidearms loaded with blanks. If a man did not have a beard, he had to pay a fine of 25¢ or go to jail for an hour at one of the brigs set up on various corners. Singing and dancing in the streets was a Pow Wow Days tradition.

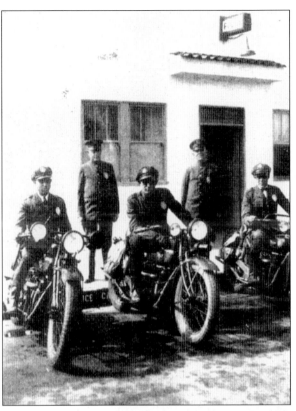

These Hawthorne police motor officers pose with their vehicles. Tommy Cummings, who spent 42 years on the Hawthorne force, is seated at the left. In the 1920s and 1930s, the officers had to purchase their own motorcycles, and the City maintained them.

The student body of Leuzinger High School is shown in 1932, the year of the school's first graduating class. Most of the school's students hailed from Hawthorne, with some coming from Lawndale. Lawndale, in which Leuzinger High is situated, was then an unincorporated portion of Los Angeles County.

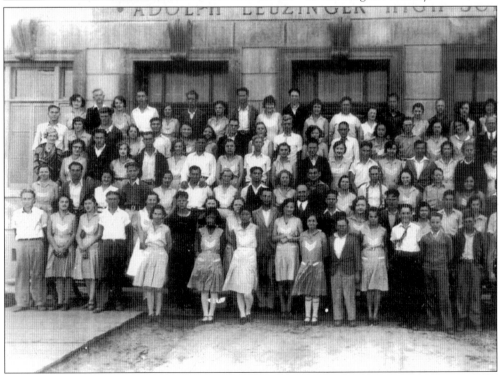

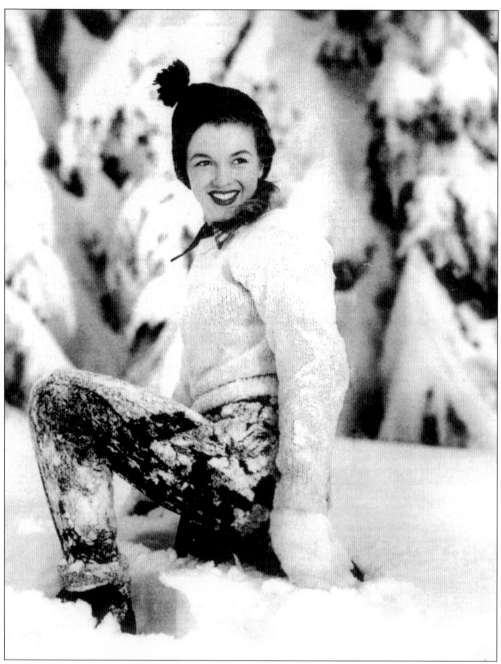

The future Marilyn Monroe, a.k.a. Norma Jeane (Mortensen) Baker, is shown in her mid-teens, several years after leaving Hawthorne. Born in Los Angeles, she lived with the Bolender family in Hawthorne from 1927 to 1934. During the region-wide disaster of the 1933 Long Beach earthquake, the little Hawthorne girl's dog, Tippy, wouldn't stop barking. "An angry neighbor, annoyed at Tippy's barking, grabbed a shotgun and killed the dog, causing the child a spasm of grief," reported biographer Donald Spoto. Descriptions of the girl's upbringing often traveled through history shrouded in a kind of Dickensian gloom.

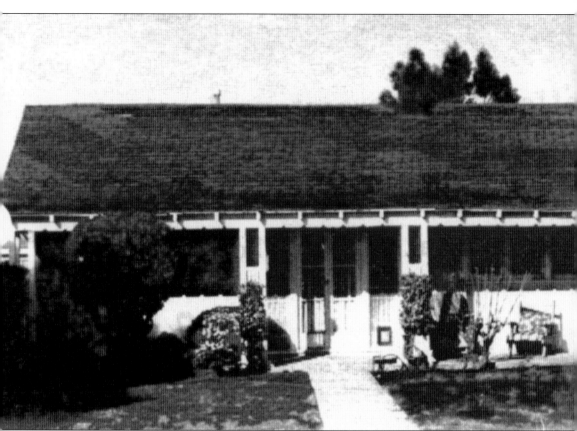

The Bolender home, located at 4201 West 134th Street in Hawthorne, was Norma Jeane (Mortensen) Baker's home for seven years. "Although there were quite different reasons to pity much in her life, the truth is (contrary to later reports) Norma Jeane's years with the Bolenders were essentially secure, she lacked for no material necessities, and there was no evidence that she was abused or mistreated," wrote Donald Spoto. The author also reported that the girl's unstable mother, Gladys Pearl Baker, often made weekend visits to take Norma Jeane on day trips to Redondo, Hermosa, and Venice Beaches for entertainment and ice cream.

Albert and Ida Bolender, the foster parents of Norma Jeane Baker, were members of a branch of the United Pentecostal Church. "They were terribly strict," Monroe is quoted as saying. "They didn't mean any harm—it was their religion. They brought me up harshly."

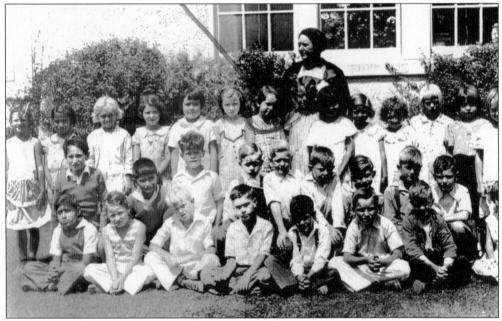

The little girl circled here is Norma Jeane Baker. This was her second-grade class photo taken in 1934 at the Fifth Street School, later known as Ramona School. The future Marilyn Monroe's birth father, an itinerant baker named Edward Mortensen, was killed in a motorcycle accident when the girl was three years old.

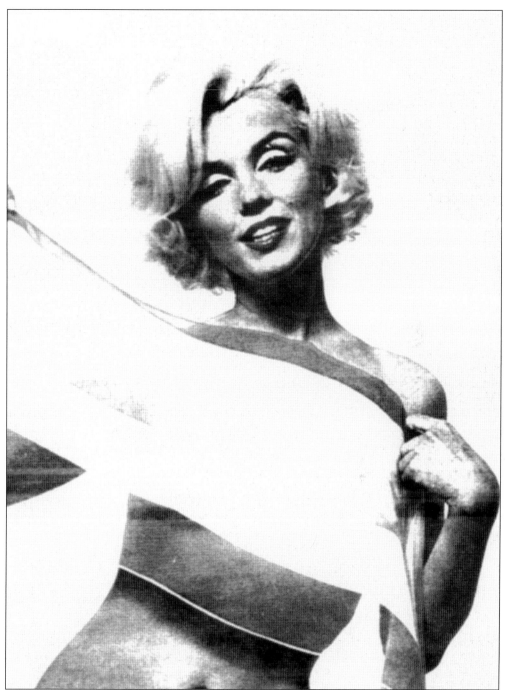

Monroe's 30-film career included *Gentlemen Prefer Blondes* (1953), *The Seven-Year Itch* (1955), *Bus Stop* (1956), and *Some Like It Hot* (1959). After very public marriages to baseball legend Joe DiMaggio and playwright legend Arthur Miller—and wide speculation about her trysts with politicians and other stars—the blonde bombshell caught the public fancy like few stars before or since. A figure of great beauty and tragedy, she died of a drug overdose in Los Angeles in 1962. Four decades after her death, she remains an American icon.

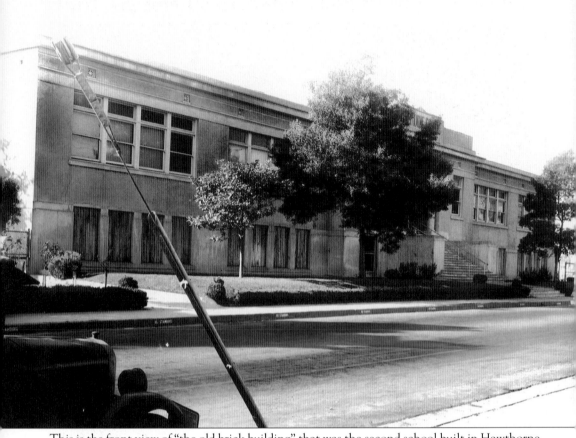

This is the front view of "the old brick building" that was the second school built in Hawthorne. It faced north on Ballona Street, which later became El Segundo Boulevard. This photo was taken in 1930.

Remodeled City Water Tower Now Veterans' Hall

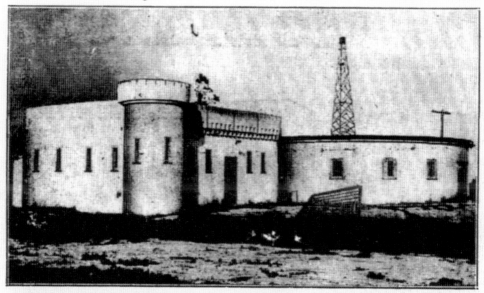

Hawthorne Veterans of Foreign Wars are making plans for a grand opening of their meeting place, the former city reservoir, which has just undergone extensive additions. The former reservoir, which resembles an old Spanish fort, will be ready for official christening on or about July 4, according to Commander B. F. Brown, Hawthorne police judge.

Times photo

Hawthorne Post Plans Grand Opening Soon

HAWTHORNE, June 21. — Hawthorne post of the Veterans of Foreign Wars has what is believed the most unusual quarters of any similar post in the country.

Its main hall is the former Hawthorne city water tank or reservoir. It was deeded to the post a few years ago for the nominal sum of $1, and since then the post has spent approximately $4000 on improvements, according to Judge Benjamin F. Brown of Hawthorne Police Court, who is Post Commander.

This year the organization has expended some $1200 on additions to the stage, hardwood floors, new card rooms and the remodeling of the old annex as well as other minor improvements. All will be in readiness for a grand opening on or about July 4, according to Judge Brown.

In the five years that the former city reservoir has been in use by the post, it has been roofed and a wing added, and the entire structure surmounted by a battlemented effect that makes it resemble an old Spanish fort. It is the intention next year to add another wing on the opposite side.

Commander Brown

Times photo

In one of the more eclectic building uses, the Hawthorne Veterans moved into the old city reservoir building in the late 1930s. This *Los Angeles Times* story said the post spent $4,000 on improvements.

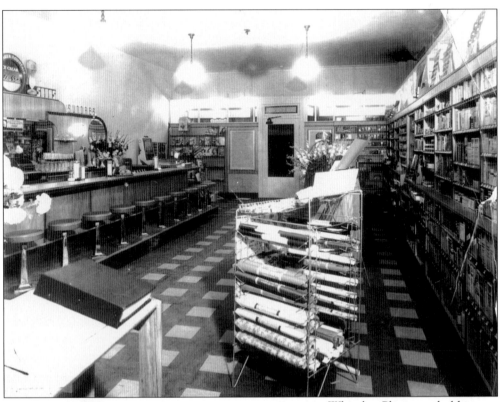

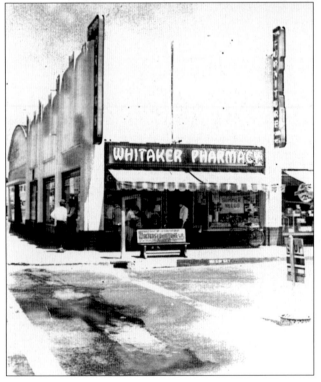

Whitaker Pharmacy held its grand opening in September 1939. The soda fountain (above) was state-of-the-art and mixed the concoctions on the spot, including popular cherry Cokes. The location was a prime Hawthorne locale, the southeast corner of Hawthorne and El Segundo Boulevards.

Four
WORLD WAR II YEARS AND AFTER

Hawthorne Boulevard is depicted in a northwest view at the Broadway intersection. Utility poles in the median were for suspended streetcar lines for the Yellow Car Number Five line. It ran from Broadway north to Los Angeles's Eagle Rock neighborhood, a trip that cost a nickel in the 1940s.

These 1940s automobiles are parked in front of the cement powerhouse that channeled power to the Yellow Car line.

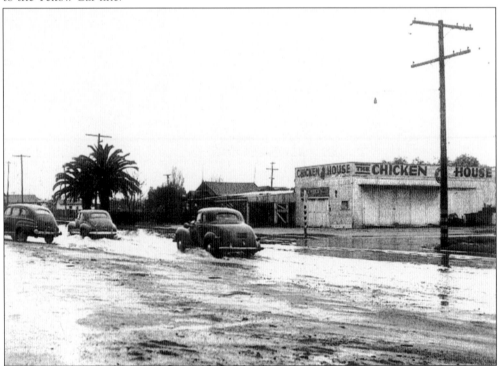

Looking south on Hawthorne Boulevard from 133rd Street, this photo captures winter street flooding. All of the chickens that were cooped up in the chicken house in the background reportedly drowned in this early-1940s flood.

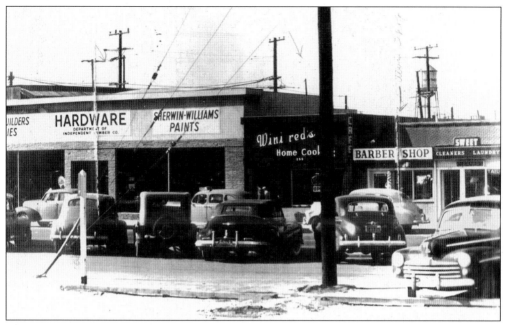

This photo shows Hawthorne Boulevard looking west just north of the railroad tracks in the 1940s. Nearly any view in downtown Hawthorne included representations of Main Street U.S.A. Here, they include a hardware store, Winifred's Home Cooking restaurant, a barbershop, and cleaners.

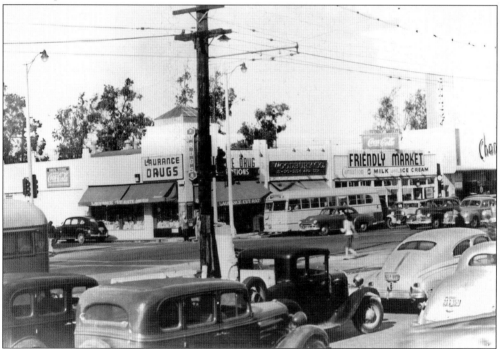

The northwest corner of Hawthorne Boulevard and Broadway is seen in the late 1940s. There were four drugstores in town then and two of them had soda fountains. The power poles carried the electrical lines for streetcars.

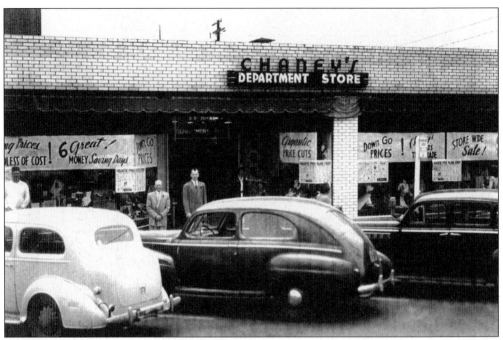

Chaney's Department Store, a hub of Hawthorne retail activity, is shown as it was in 1944. It was located north of Broadway on Hawthorne Boulevard's west curb.

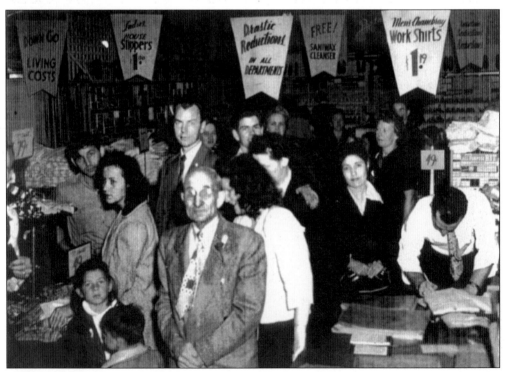

Thorwald "Papo" Emerson was manager of Chaney's Department Store. In this 1947 photo he conducts a sale. Work shirts could be had for $1.19 apiece, and a pair of slippers went for $1.

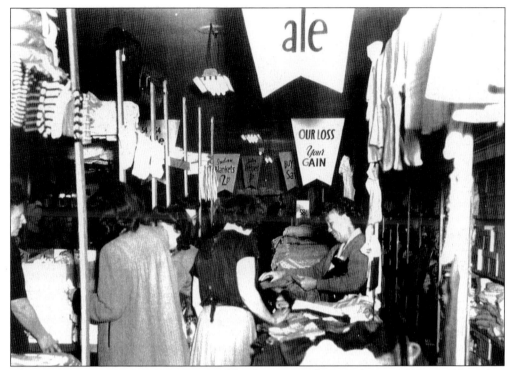

Chaney's Department Store was captured by the camera during a hectic 1947 sale. Note that the price of an Indian blanket was $2.39.

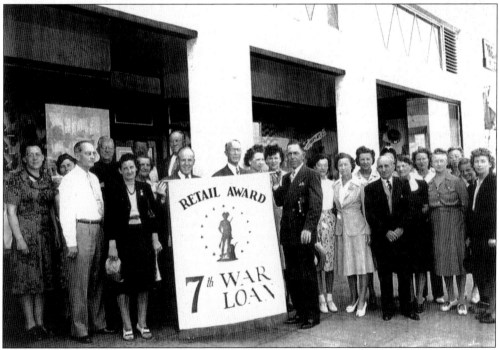

In 1944, Mr. Chaney and his staff received an award for participating in the seventh war loan drive. Mr. Chaney is seen just above the "RE" in the sign.

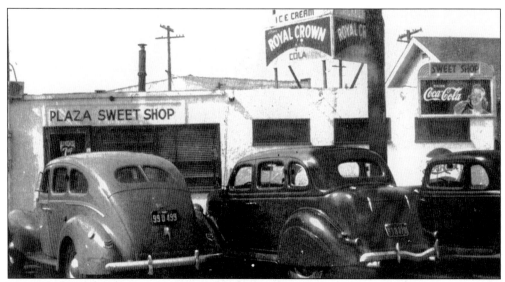

The Plaza Sweet Shop, seen here in the 1940s, was located just across the street from the Plaza Theatre. "Pop" West owned the shop, which was the top hangout for high school kids for more than a generation. If teens argued or caused a disturbance, Pop would order the offenders from the establishment and bar them for 24 hours. All the other kids upheld the respect for Sweet Shop etiquette by agreeing not to speak to the offenders for the same 24 hours. At center-right is a 1934 Plymouth De Luxe coupe that was owned by co-author Walt Dixon.

PLAZA SWEET SHOP

HOT FUDGE

SUNDAES

10c

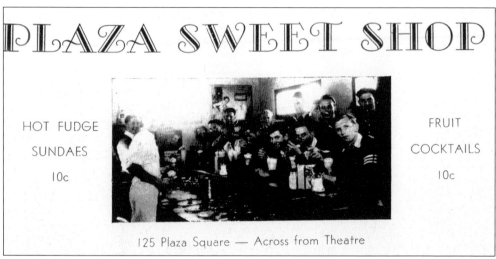

FRUIT

COCKTAILS

10c

125 Plaza Square — Across from Theatre

The Plaza Sweet Shop's soda fountain was one of the main gathering spots to have a snack and trade neighborhood news. Proprietor "Pop" West closed the door at 10 p.m. Ten was the operative number in the late 1930s and early 1940s as hot fudge sundaes, fruit cocktail, malts, and hamburgers were all 10¢ each.

Looking west between Broadway and 126th Street, this photo shows Rasco's Store—one of two in Hawthorne that were known as "five-and-dimes," the liberal interpretation meaning from a nickel to under a dollar.

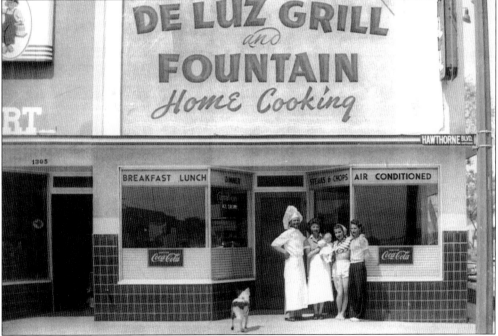

The DeLuz Grill and Fountain was located at Hawthorne Boulevard and 140th Street. After it closed its doors in the 1940s, the Dutch Boy Paints next door expanded to take over the building. The Dutch Boy Paints store was owned by Frank Prenovost.

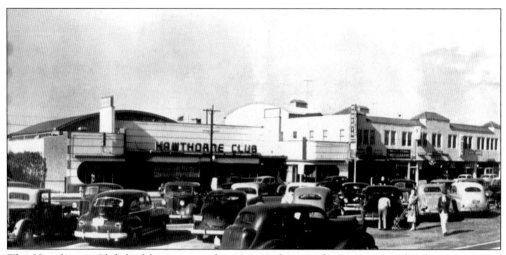

The Hawthorne Club had been a social center in the city for generations by the time it was demolished in 1962. A nightclub known throughout the South Bay region, the Hawthorne Club housed a bowling alley and had been the scene of prizefights and marathon dances. Here, the Hawthorne Club and the adjacent Jones Building are shown in the 1940s. Both held dozens and dozens of dances and civic banquets.

The Los Angeles County Public Library's Hawthorne Branch is pictured in 1947. It was located on Acacia Avenue, north of El Segundo Boulevard.

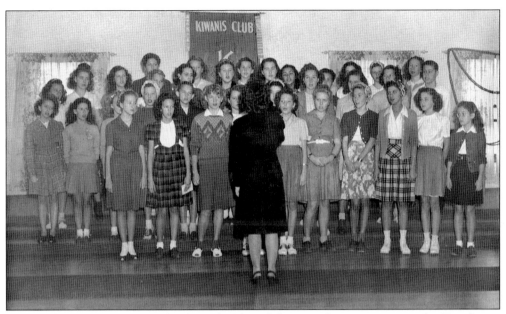

The Washington Grammar School's Girls Glee Club is seen here entertaining the Hawthorne Kiwanis Club in the 1940s when E.J. Parker was president of the Kiwanis Club.

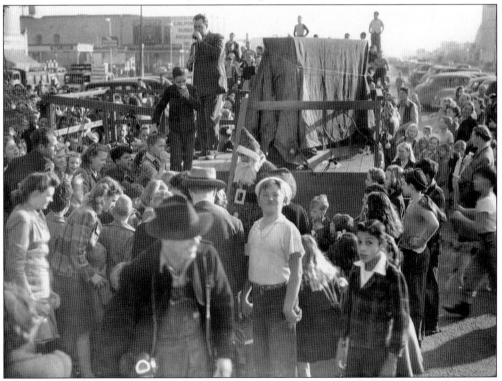

An annual "Open Christmas Party" for the kids of the city was thrown by the Hawthorne Kiwanis Club. At the microphone is Clyde Walker, chairman of the Boys and Girls Committee. One youngster in a sailor's hat (center) seems to command his own attention. This event was held in 1946 at Hawthorne Boulevard and Plaza Square.

This is a section of Hawthorne Boulevard looking north from 133rd Street. It illustrates a pavement standard that started in the 1920s and was still the state of the roads in the 1940s. The first 20-foot-wide strip of pavement is viewable on the right as a car heads north. The rest of the right-of-way on either side is dirt that had been oiled and rolled.

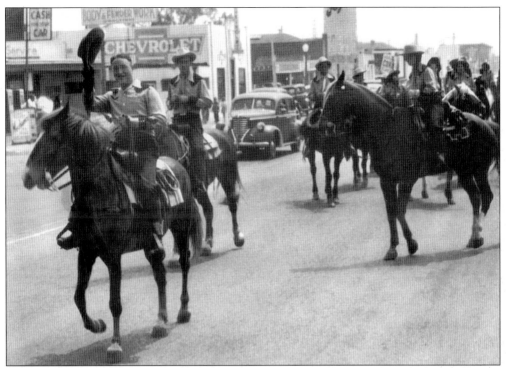

The Golden West Riding Club shows its stuff during the 1948 Hawthorne Community Parade. Riding club president R.L. "Rosie" Whitaker is shown atop "Honey" in the front row.

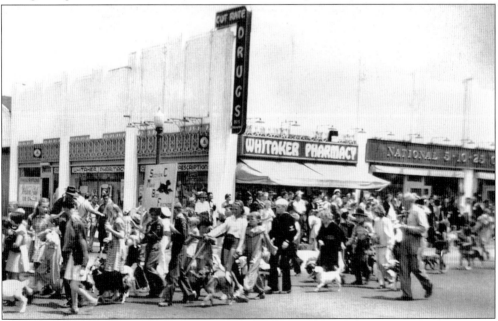

During World War II, there wasn't much diversion and a lot of locals were working in area defense plants. Any excuse for entertainment was welcomed. This 1944 parade was dubbed "Man's Best Friend." Anyone with a dog—or anyone who could borrow one—did so, and merged into the Hawthorne Boulevard stroll.

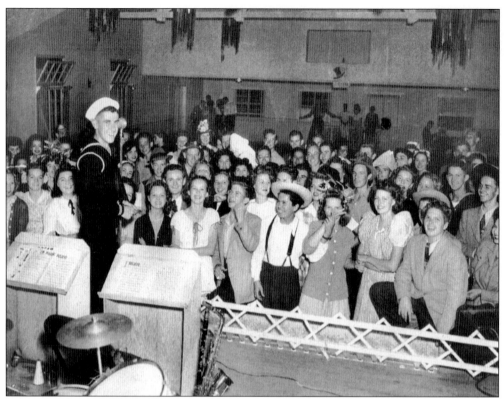

Teens are shown here at Club Gunga Din in the late 1940s. The club was founded by a Leuzinger High School teacher to foster in students a community spirit. At Club Gunga Din, they met, socialized, and coordinated projects to benefit Hawthorne's citizenry. Here, a sailor seems particularly welcome.

Club Gunga Din was built for $45,000 in 1945 for Hawthorne teens. The club was erected on the fringe of a city park by permission of the city council.

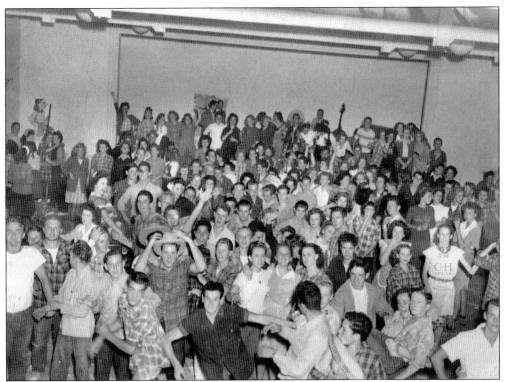

This enormous pep rally was one of the activities hosted at Club Gunga Din, one of the city's unique gifts to its youth.

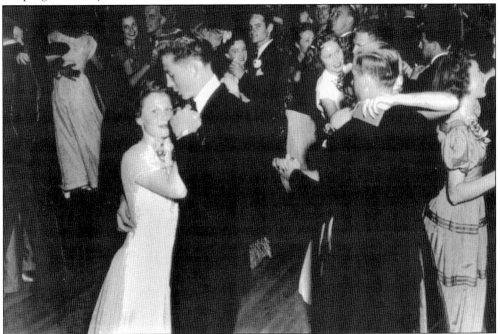

Club Gunga Din was a focal point for students to hone social skills. Here, the teens are involved in a formal dance.

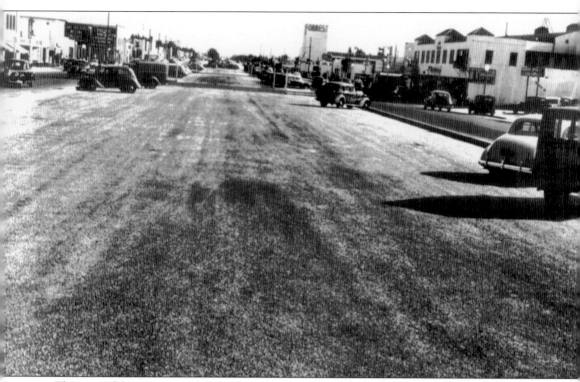

This peaceful 1940 view of Hawthorne Boulevard looking south shows the Brown Building, the first structure on the right side. The boulevard would never again seem so calm and free of traffic.

Five
THE PROSPEROUS 1950s

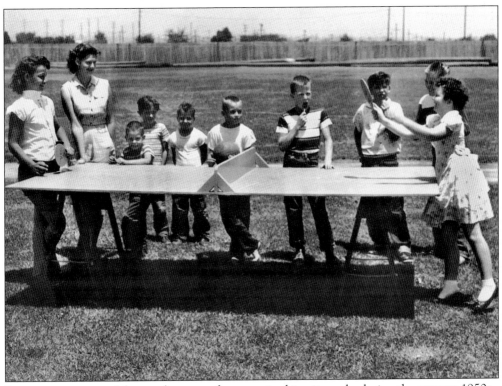

Ping pong was one of the youth sports often practiced in city parks during the postwar 1950s.

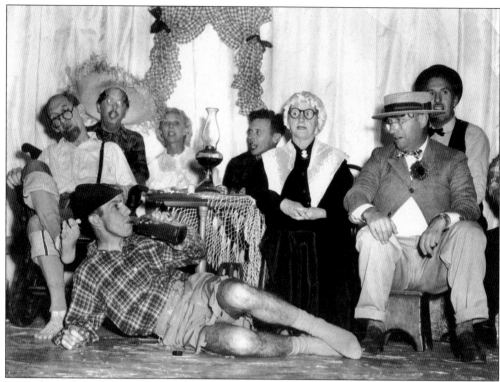

Little local theatre groups proliferated during and after the war. The performers here were photographed for what appears to be a publicity pose for a bucolic, *Tobacco Road*–style play. The theatre for this late-1950s production was located at Prairie and 139th Street.

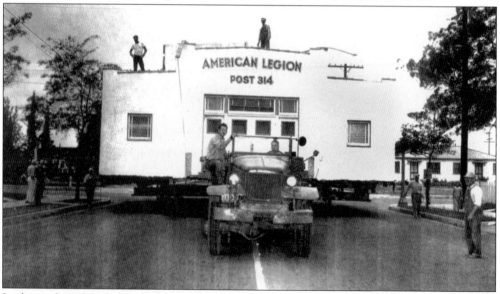

In this early 1950s photo, the Koeller brothers move American Legion Post 314 eastward, from Broadway to Prairie. The Koeller brothers were longtime Hawthorne residents and businessman who participated in many house moves. The house-moving trade was a steady business in prewar and postwar Los Angeles County.

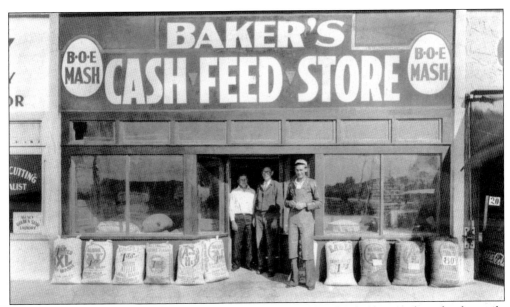

Baker's Cash Feed Store stacked the grain sacks neatly under the display windows for this early 1950s photo.

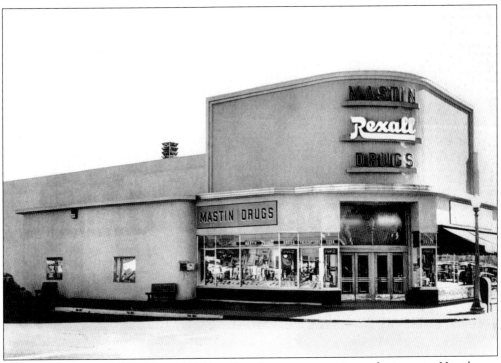

Mastin Rexall Drugs, located at 100 East Broadway, was a mainstay business in Hawthorne through the war years and the 1950s. The pharmacist was Grant H. Mastin.

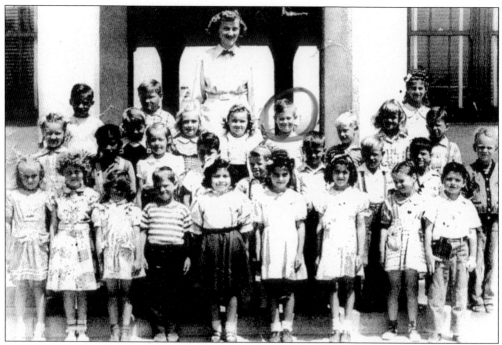

This photo of Mrs. Wilson's fourth-grade class at York Street School in the late 1940s shows one smiling face encircled. That young man is Brian Wilson, who later sang with the Beach Boys. Teens who converged to establish this legendary pop group soaked up the atmosphere on Manhattan, Hermosa, Redondo, and other South Bay beaches—but they hailed from landlocked Hawthorne.

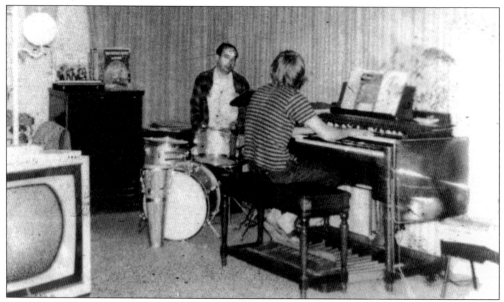

The Beach Boys are seen here practicing in Gil Linder's home. Linder, who owned a television-repair business, lived next door to the Wilsons. Dennis Wilson, who became known by contemporaries and around town as "Dennis the Menace," is shown on the keyboards. Brian Wilson traded his guitar to Linder for the repaired television set seen in the left foreground.

In the 1950s, The Beach Boys were just a group of teenagers from Hawthorne High School. Brian Wilson, the sparkplug of the group, lived at 3701 West 119th Street, at the corner of Kornblum. The group would practice at Gil Linder's house. The Wilson brothers are pictured at the top—Dennis, Carl, and Brian—with Mike Love at the center and Al Jardine at the bottom. Their classic songs epitomize the spirit of the California lifestyle, and The Beach Boys have become American icons. Their first hit, "Surfin' " (1961), launched a string of chart-topping songs that spans 40 years: "Surfer Girl," "California Girls," "Help Me Rhonda," "Good Vibrations," "Wouldn't It Be Nice," "Fun, Fun, Fun," "I Get Around," "Barbara Ann," "Rock and Roll Music," "Kokomo," and many others.

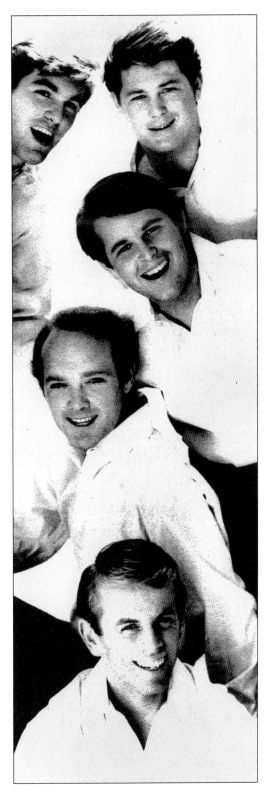

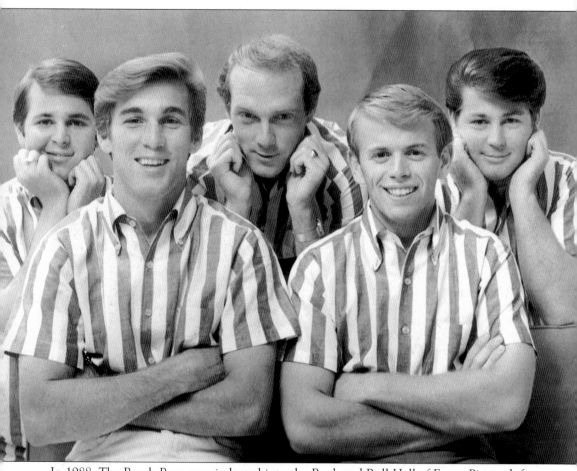

In 1988, The Beach Boys were inducted into the Rock and Roll Hall of Fame. Pictured, from left to right, are Carl Wilson, Dennis Wilson, Mike Love, Al Jardine, and Brian Wilson. They recorded 32 albums that went gold or platinum.

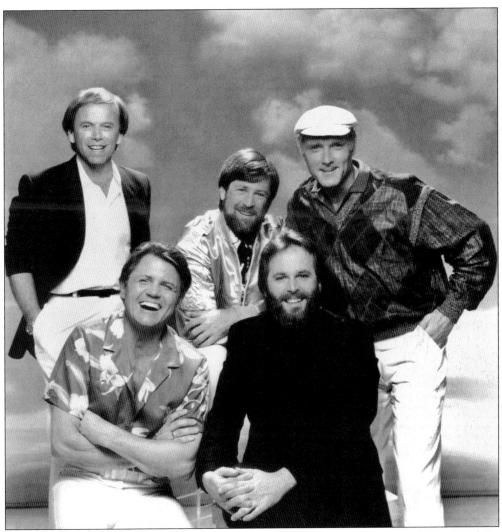

Here are The Beach Boys in their later years. One *Rolling Stone* magazine ranking placed *Pet Sounds* as the number-two best album of all time. The Beach Boys received the Lifetime Achievement Award at the 2001 Grammy Awards.

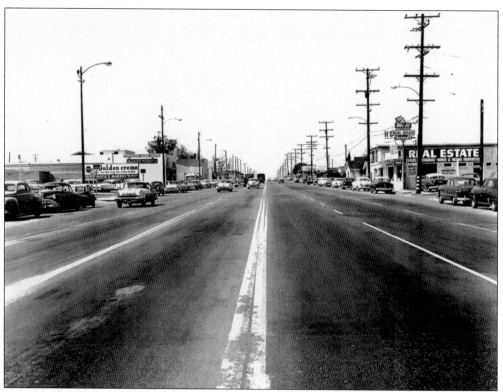

This view of El Segundo Boulevard looking west of Hawthorne Boulevard was taken in 1956. The building on the left past the Golden Creme sign is the present location of the Hawthorne Chamber of Commerce.

This is a 1950s view of Hawthorne Boulevard looking south from Imperial Highway. A Ferris wheel is detectable about a block beyond the car on the righthand side. There, at Hawthorne and 117th Street, a small amusement park ran year-round.

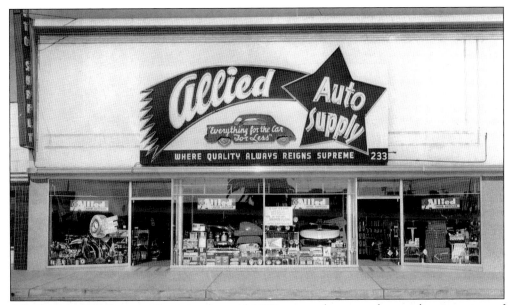

Allied Auto Supply, seen here in the mid-1950s, started out at the northwest corner of Hawthorne Boulevard and 126th Street, and moved to the west side of the boulevard south of 129th Street.

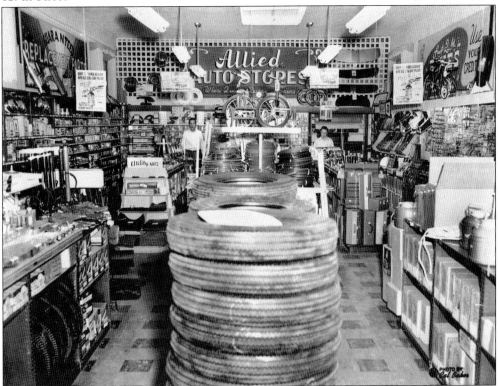

Allied Auto Store was a busy location for car owners, mechanics, and bicyclists, and one of the city's more bustling establishments in the postwar era. Note the hand tire pumps on the shelf to the left.

One Hawthorne resident climbed very high in statewide politics: Glenn Malcolm Anderson. Born in the city on February 21, 1913, he received his B.A. from UCLA in 1936. Anderson was Hawthorne's mayor from 1940 to 1942, then was elected to the state assembly and served from 1942 to 1948. Anderson was lieutenant governor of California from 1959 to 1967 under Gov. Edmund G. "Pat" Brown. Anderson's other achievements included serving as chairman and member of the state lands commission, 1959 to 1967; member of the board of trustees of California State Colleges, 1961 to 1967; and Democrat electee to the 91st and then 11 succeeding Congresses (January 3, 1969, to January 3, 1993). He died on December 13, 1994, and is interred at Green Hills Cemetery in Rancho Palos Verdes, California.

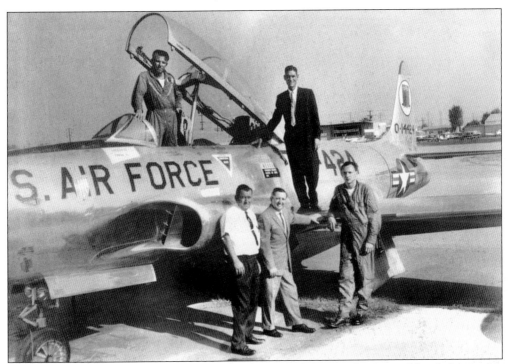

An F-80 jet pulls in for a stop at Hawthorne Airport. Standing on the wing is Hawthorne mayor Jim Wedworth, who owned Phil's Bike Shop at Hawthorne Boulevard and 132nd Street. Wedworth later served in the state assembly and was defeated in a gubernatorial run. On the runway, from left to right, are city manager Joy West and Parks and Recreation Department director Cossie Smith.

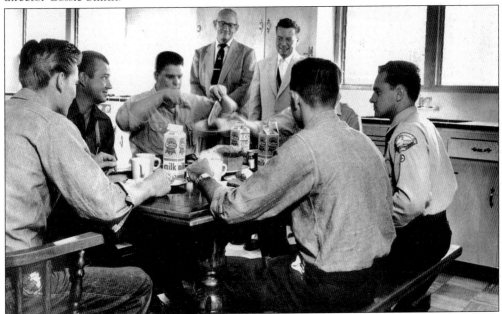

In the early 1950s, firemen in the old City of Hawthorne Fire House on Plaza Square enjoy a meal prepared by one of their own.

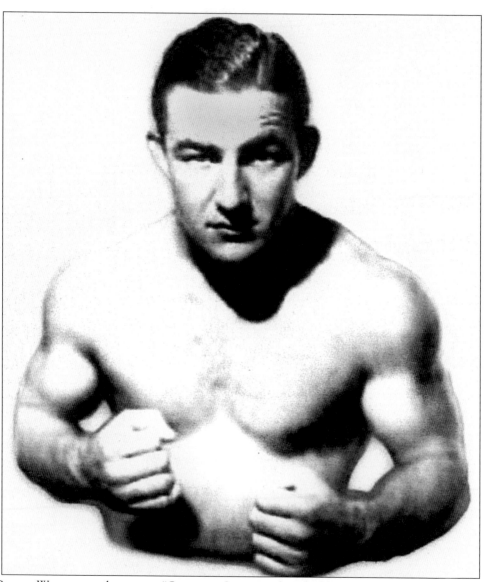

George Wagner was known as "Gorgeous George" when he became a nationally renowned professional wrestler on television from the late 1940s through the early 1960s. But around Hawthorne, he was once just plain George, the local mild-mannered milkman. In the ring, he wore flamboyant gowns, had blond locks with gold-plated bobby pins, and often sneered at ringside patrons and called them "peasants." The wild wrestler could be seen driving through town in one of his lavender Cadillac convertibles, curls blowing in the wind. He claimed that Liberace stole his candelabra theme after Los Angeles–area fire marshals told George to keep the dangerous prop out of his arena matches. He was truly a pop-culture icon. "A more famous or controversial figure could not be found," averred the *Ring Chronicle*. "It was said that during his prime, George was more well-known than the President." The more sedate *The Complete Directory to Prime Time Network TV Shows* recounted the early 1950s when televised wrestling made a huge impact and televisions were not yet in every home: "Names like Gorgeous George, Antonino 'Argentina' Rocca, and The Mighty Atlas were household words among the owners of TV sets."

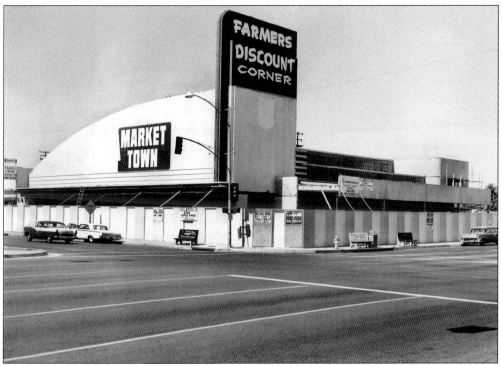

Farmers Discount Corner was located on the southwest corner of Hawthorne and El Segundo Boulevards, and lasted into the 1960s. Many businesses have occupied the same building, which was originally constructed by Walter Forrest as a market. His first store, Forrest Market, was just located across Hawthorne on the east curb.

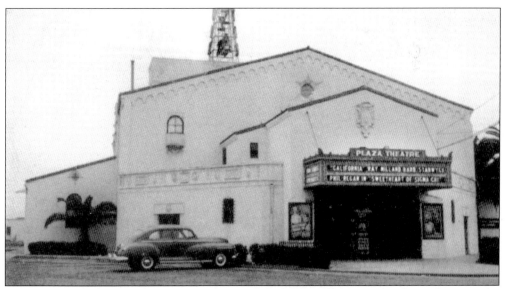

Another Hawthorne landmark that transcended the decades was the Plaza Theatre. The marquee here proclaims a double feature with Barbara Stanwyck and Ray Milland in *California*, and Phil Reagan in *Sweetheart of Sigma Chi*.

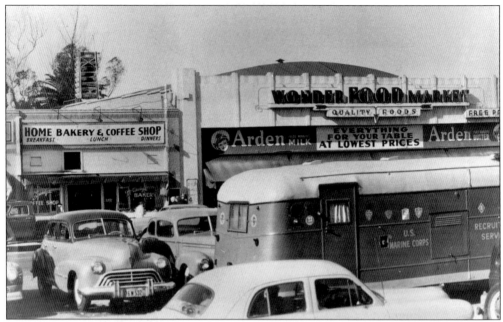

The southwest corner of Hawthorne Boulevard at Broadway featured the Wonder Market, where pop star Sonny Bono worked as a box boy in his teen years. Bono was eventually one half of the famed duo Sonny and Cher. He would go on to be elected mayor of Palm Springs and, in 1994, a United States congressman. He died in a skiing accident.

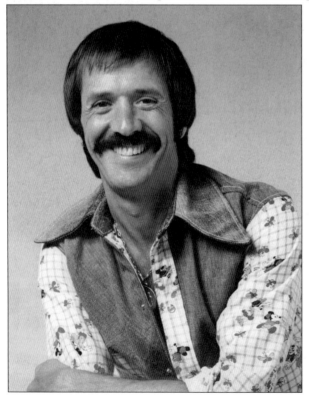

Sonny Bono graduated from Inglewood High School in 1951. Bono's first marriage in 1954 to Donna Rankin was years prior to his nuptials with Cher and was performed in Hawthorne. Bono starred in *The Sonny and Cher Comedy Hour* from 1971 to 1977 on CBS. Sonny and Cher's hit tunes included "The Beat Goes On" and "I've Got You, Babe."

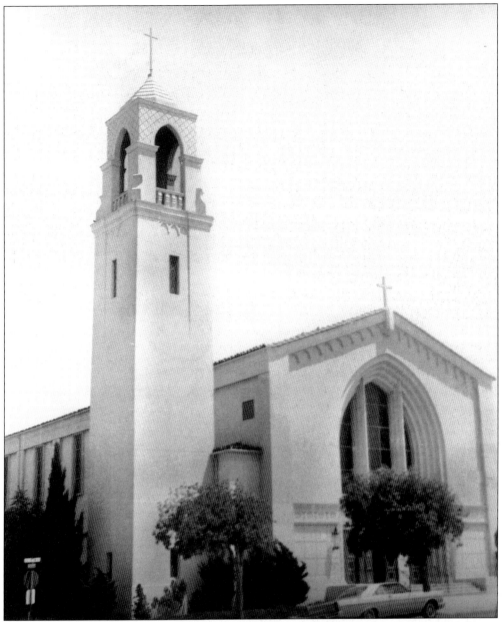

This is St. Joseph's Church at 119th Street and Acacia Avenue in the 1960s, where Sonny Bono married his first wife, Donna Rankin.

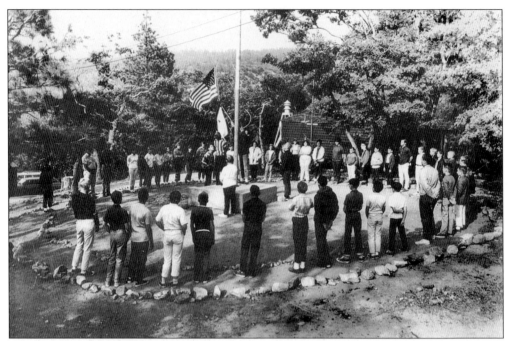

This flag-raising ceremony was conducted by Hawthorne youths at Wrightwood in the 1950s. Wrightwood, located in the San Gabriel Mountains on the northern edge of Angeles National Forest, is the site of the city of Hawthorne's Youth Camp for fifth and sixth graders.

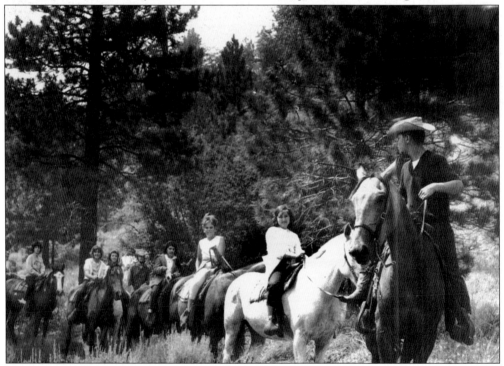

A horseback ride is conducted for the Hawthorne Intermediate School's fifth and sixth graders at the Hawthorne Youth Camp in the mountains.

In the 1950s, prior to any improvements, Holly Glen's original baseball field had that uncomplicated sandlot look.

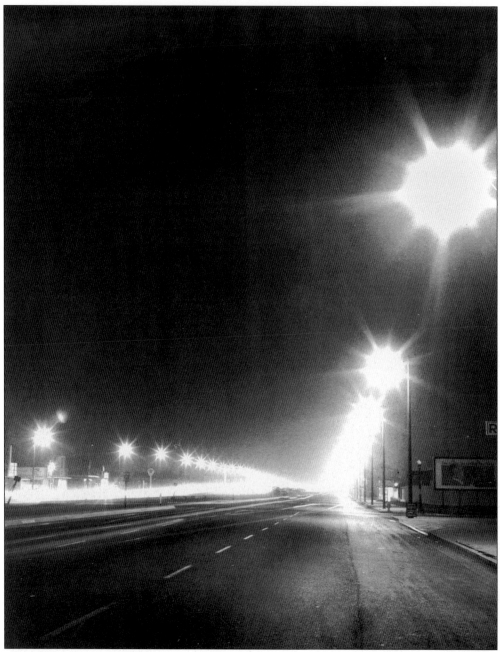

This photo was taken at 2:30 a.m. on February 11, 1954, at 141st Street, looking north along Hawthorne Boulevard. It illustrates the gritty urban look of Hawthorne at night.

Six

HAWTHORNE KIWANIS PARADE

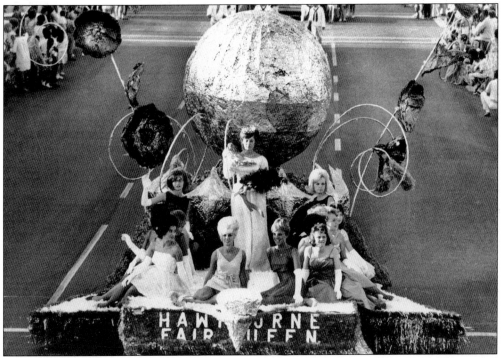

The Hawthorne Fair queen and her court are shown on the queen's float during the annual Hawthorne Kiwanis Parade in 1962. The fair and parade were region-wide events in the 1950s and 1960s. The parade was often televised throughout Southern California and was considered in prestige second only to the Tournament of Roses Parade in Pasadena. Entrants in the parade were offered spots on an invitation-only basis.

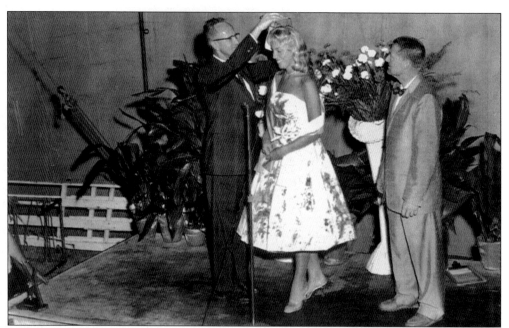

Bill Welch of KTTV, Channel 11, in Los Angeles crowns the first Hawthorne Kiwanis Club queen during the 1959 Kiwanis Fair, at the location of the present-day Memorial Center. At that time, a circus-style big-top tent housed all of the fair exhibits. The crowning was held on the back of a flatbed truck. At right is co-author Walt Dixon, chairman of the queen contest.

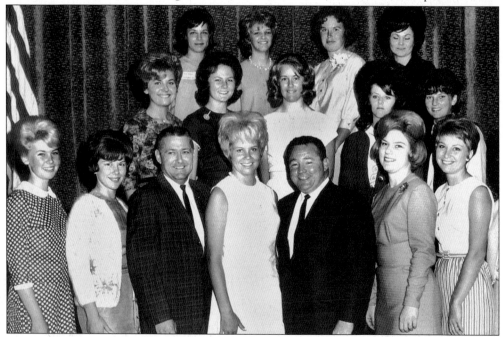

The two men pictured are Walt Dixon, left, and B.J. Clack. The women are all contestants for the annual queen contest in 1960. It wasn't a beauty pageant; it was a contest won by a raffle. The Kiwanis used to net about $45,000 a year from the contest. The proceeds benefited boys and girls clubs and underprivileged families.

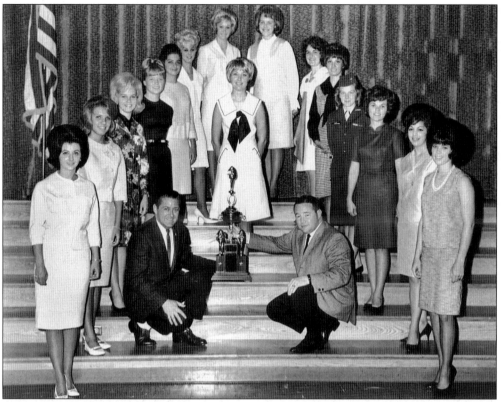

This publicity photo of the Kiwanis Club Parade's queen and her court was taken in 1961 with co-chairs B.J. Clack—who eventually became lieutenant governor of Division 19 of the Kiwanis—and Walt Dixon.

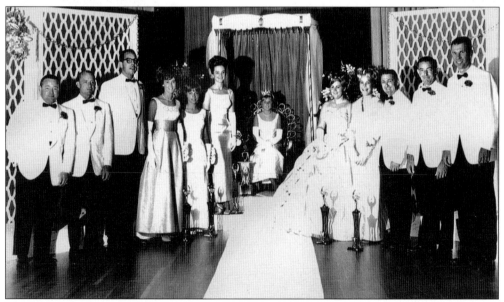

The formal Coronation Ball was held in the main room of the Hawthorne Memorial Center in 1963. After the crowning all the guests enjoyed a dance that lasted into the night.

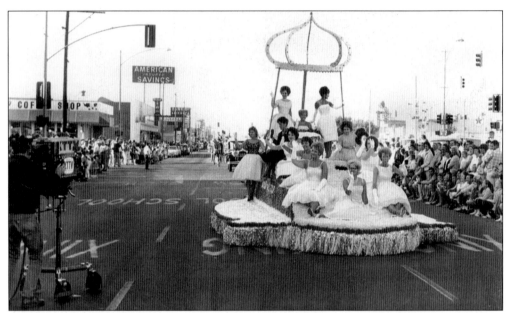

A float carries the queen and her court in this early 1960s photo. A KTTV camera capturing the action can be seen at the extreme left. The throngs of people who gathered along Hawthorne Boulevard for the event brought the town a lot of annual business.

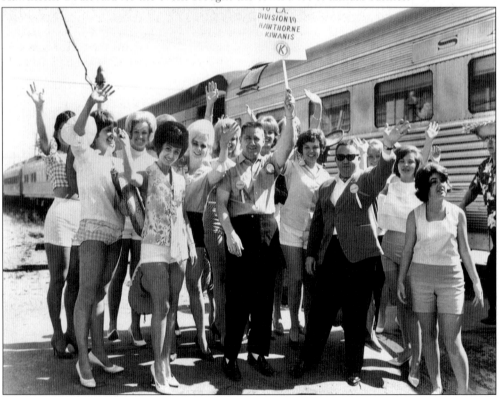

This publicity photo for the Hawthorne Kiwanis Parade's queen contest shows the contestants with Walt Dixon and B.J. Clack welcoming the Kiwanis 19th Division Convention in 1959.

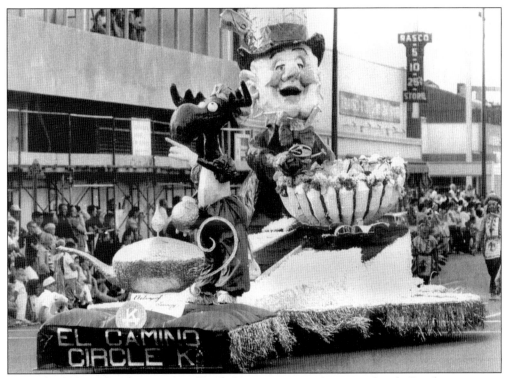

The Hawthorne Kiwanis Parade offered the opportunity for some South Bay businesses to combine forces on floats. Here El Camino College forged an alliance with Circle K Markets to carry some favorite animated characters, including the Jay Ward-created favorite, Bullwinkle the Moose.

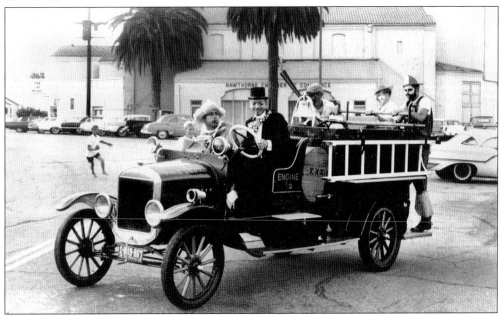

The Hawthorne Fire Department came to the rescue in an old Model T Ford fixed up as a fire truck. The firemen look a bit fixed up, too.

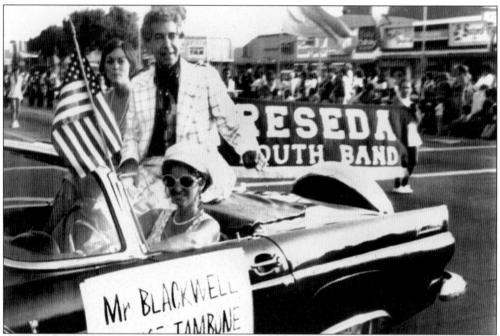

Among the celebrities who made appearances in Hawthorne Kiwanis Parade was Mr. Blackwell, whose judgments on the best- and worst-dressed celebrities of each year became an annual national sideshow. A former child actor, Mr. Blackwell's actual name is Richard Selzer. His plaid-on-plaid look in the parade here apparently was in vogue for his own style in the 1960s.

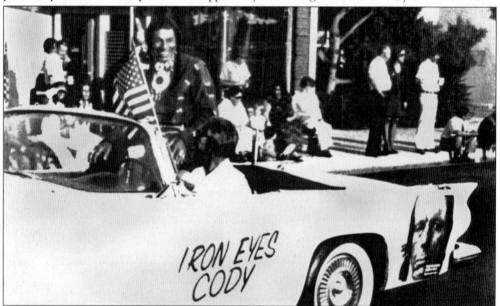

Character actor Iron Eyes Cody shows enthusiasm in the parade. In the 1960s Cody became an icon of the environmental movement as a canoeing Native American shedding a tear over the pollution of rivers. He played in hundreds of movies and television shows. In a career of remarkable longevity, he was an extra in 1919 at age 12 in *Back to God's Country* and was as a featured player in 1991 in *Spirit of '76*.

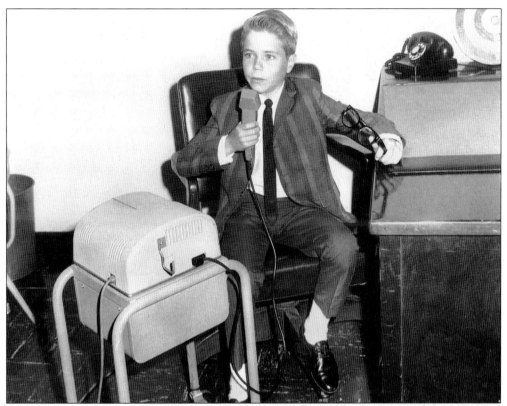

Jon Provost, who was better known as Timmy (the main pal of *Lassie* on CBS from 1957 to 1964), was also a guest of the Hawthorne Kiwanis Parade. In this *c.* 1962 photo, Provost answers questions at a press conference.

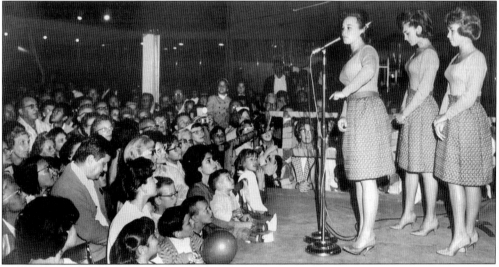

Performing at the Hawthorne Fair in the early 1960s are the Lennon Sisters—Peggy, Kathy, and Janet—who were made famous by their regular television appearances on ABC's enduring *The Lawrence Welk Show*. Only three of the four Lennons made the gig as Dianne left the group from 1960 to 1964 to begin raising a family.

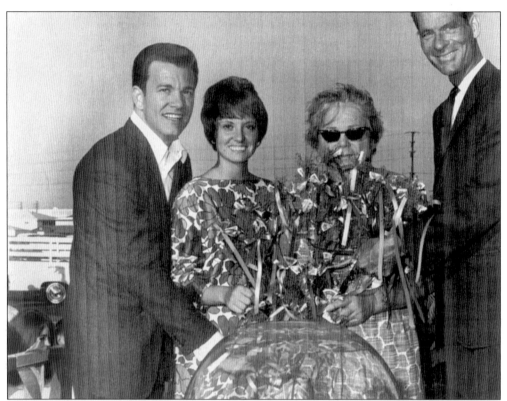

Wink Martindale, the host of such television game shows as *Gambit*, *How's Your Mother-in-Law?*, and *Tic Tac Dough*, poses with one of the Hawthorne Fair queens as well as Lee Whitebrook (the editor, publisher, and owner of the local newspaper the *Hawthorne Press*), and Mayor James Q. Wedworth as they prepare to draw raffle tickets from a huge fishbowl in 1964.

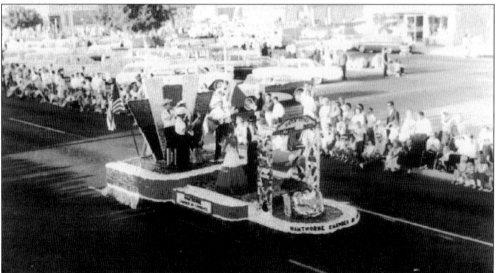

The chamber of commerce float in a mid-1960s edition of the parade has a distinctive Mexican flavor, with the southerly nation's colors, celebratory costumes, and even a mariachi band aboard.

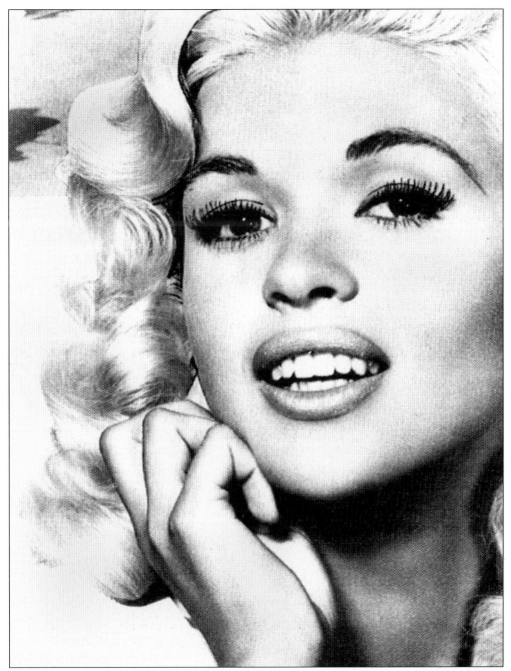

Jayne Mansfield was grand marshal of the Hawthorne Kiwanis Parade for two years in a row in 1963 and 1964. The buxom, platinum blonde graciously enjoyed mixing with the locals during both parades. The star of such films as *The Girl Can't Help It* (1956) and *Will Success Spoil Rock Hunter?* (1957) rode a horse each year down Hawthorne Boulevard. Other grand marshals included Los Angeles celebrities Kenny Hahn and George Putnam. Guests in the parade in various years included Wink Martindale, Jeff Edwards, Jon Provost, Rudy Vallee, and astronaut Buzz Aldrin.

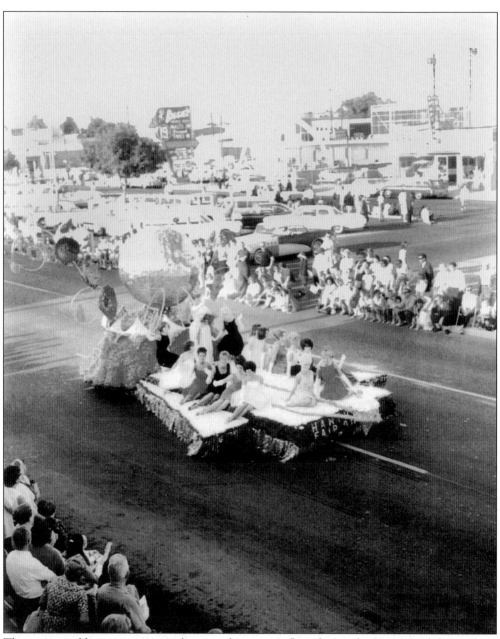

The queen and her court are seen here on the queen's float during the Kiwanis Club Parade in 1965. Always a boon for the local economy, the parade drew curbside watchers from throughout Southern California.

Seven

THE 1960S AND BEYOND

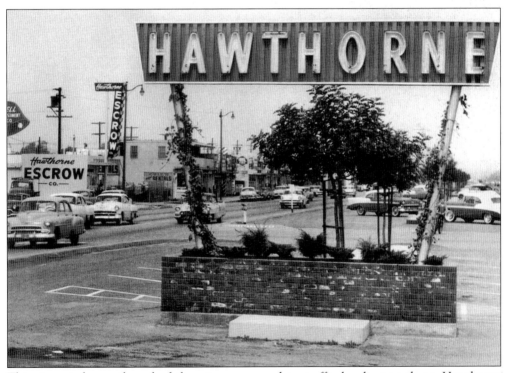

This sign at the south end of the city announced to traffic heading north on Hawthorne Boulevard that it was entering Hawthorne (and leaving Lawndale) in 1960. The Escrow building on the left became a photo processing store.

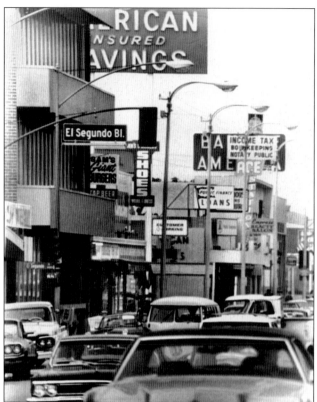

The signs of the times sprang up throughout the 1950s so that by the 1960s drivers could (carefully) read their way along Hawthorne Boulevard. This shot looks north at El Segundo Boulevard. The American Savings became a Washington Mutual bank.

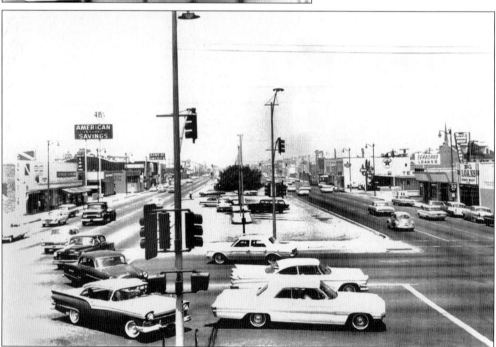

Looking north, this shot shows another view of the northwest corner of Hawthorne and El Segundo Boulevards.

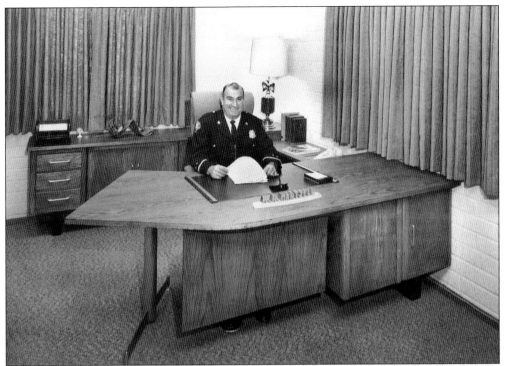

Former fire chief Robert "Bob" Hartzell sits at his desk in the new fire/police station in the 1960s. Hartzell helped to identify many of the places and names in the vintage photos used in this book.

The city's police and fire departments were both housed in an L-shaped building from the 1940s thorough the 1990s.

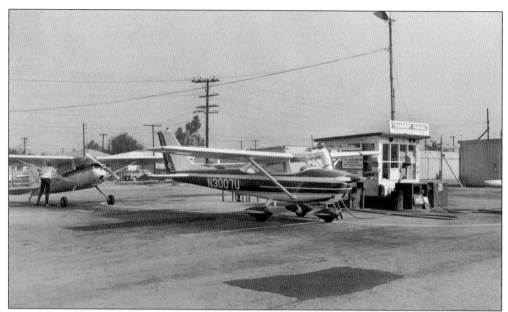

The original gas pit at Hawthorne Airport was fully equipped for its era—with its one hose. This shot was taken in 1960. The airport served the needs of a wide variety of planes, and was the site of various productions including the television shows *Knots Landing, Days of Our Lives, MacGyver,* and the films *The Limey* (1999) with Terence Stamp and *Miss Congeniality 2: Armed and Fabulous* (2004) with Sandra Bullock.

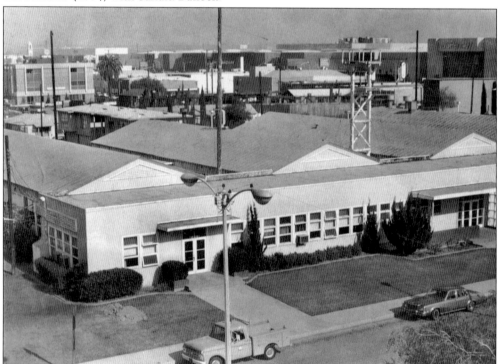

The Naval Reserve Armory is depicted in this mid-1960s photo of 126th Street, where the present Hawthorne City Hall is located.

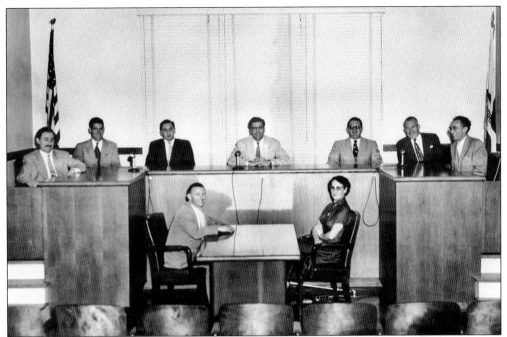

Pictured during this Hawthorne City Council meeting in the mid-1960s from left to right, are Sam Rice, Jim Wedworth, Dave Rice, mayor Vic Zaccalian, Champ Clark, unidentified, and Bob Reeves. Also shown are city clerk Kenny Keel and city treasurer Lou O'Rourke.

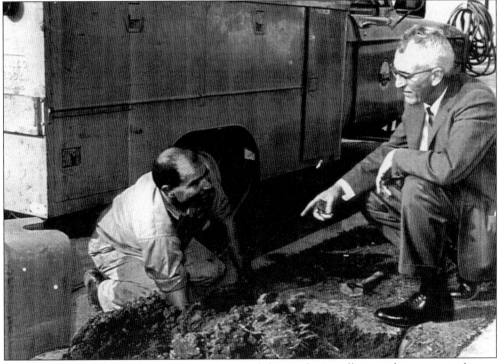

Longtime city employee Henry "Hank" Desmond directs the installation of a new water line in the 1960s.

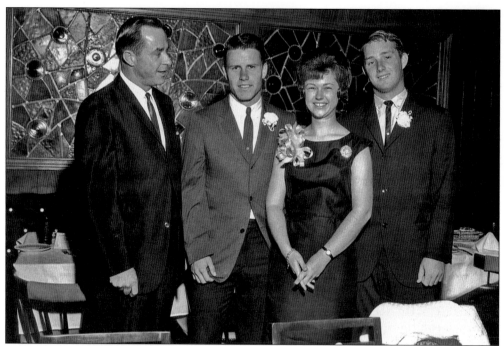

Mayor Raymond Creal congratulates the incoming officers of the Hawthorne Youth Canteen at an April 6, 1963 dinner. From left to right are Creal, youth canteen president Steven Smith, secretary Billie McNabb, and vice president Dennis Nesteby.

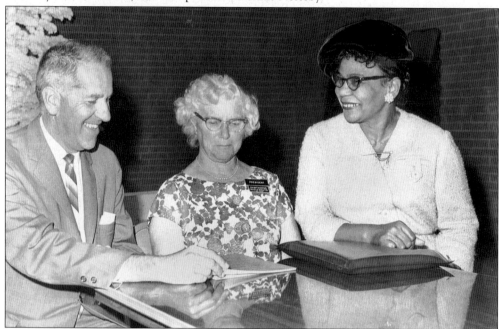

The Hawthorne Information Day program plans are finalized in the early 1960s by Wally Nyman, Ina Reed of the Gad-A-Bouts, and Flora Chisholm of the Los Angeles County Department of Senior Citizens Affairs. Nyman Hall in Hawthorne High School is named for Nyman, who was formerly vice principal of Leuzinger High School in Lawndale.

Youngsters participate in games at the Hawthorne Youth Center. During the 1960s, they would gather regularly at the center on Saturdays.

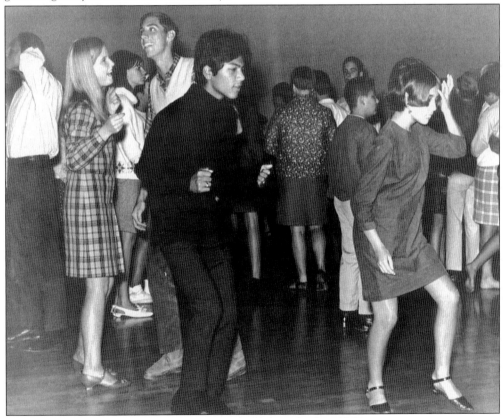

This dance was held at the Hawthorne Youth Club in the late 1960s.

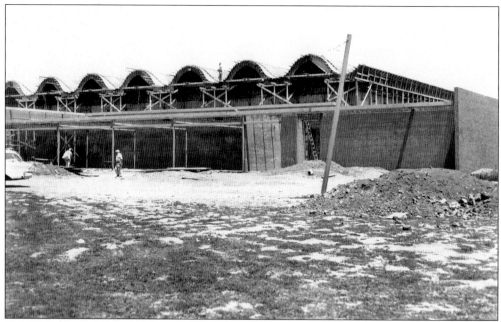

The Hawthorne Memorial Center is seen here during its construction in the mid-1960s on El Segundo Boulevard, just east of Prairie Avenue. Located next door to it is the Betty Ainsworth Sports Center, named for the first woman mayor in the city's history, who served from 1985 to 1991.

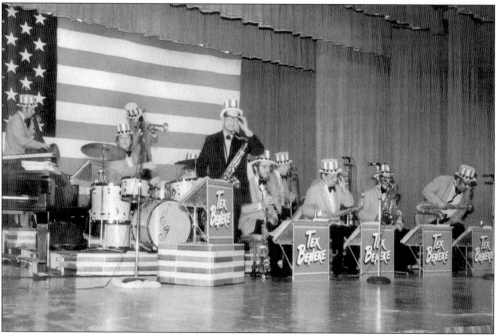

Tex Beneke and his band play at a function in the Hawthorne Memorial Center in the late 1960s or possibly early 1970s. Beneke was once the vocalist for the Glenn Miller Orchestra. The center, which houses the Senior Center and holds many functions during the year, is operated by the parks and recreation department.

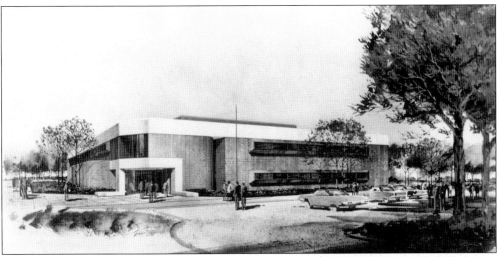

This is an artist's rendering of what the present Hawthorne City Hall at 4455 West 126th Street would look like—and did.

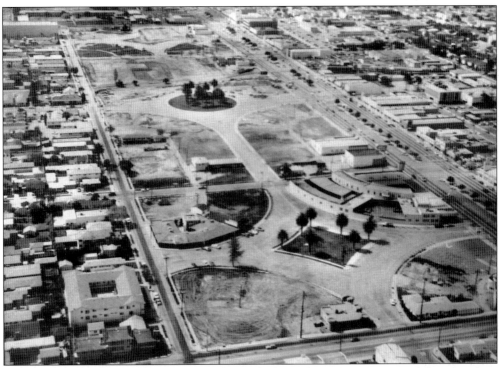

The Plaza Theatre in Plaza Square, which was built in the 1920s, was one of the many city landmarks torn down in the 1970s to make room for the Hawthorne Mall. The view here looks north on Hawthorne Boulevard at Plaza Square where the mall was built. The traffic signal on the left is Broadway. The mall was occasionally used by Hollywood; films made there include *Evolution* (2001) with David Duchovny, Steven Spielberg's *Minority Report* (2002) with Tom Cruise, and *Soul Plane* (2004) with Snoop Dogg.

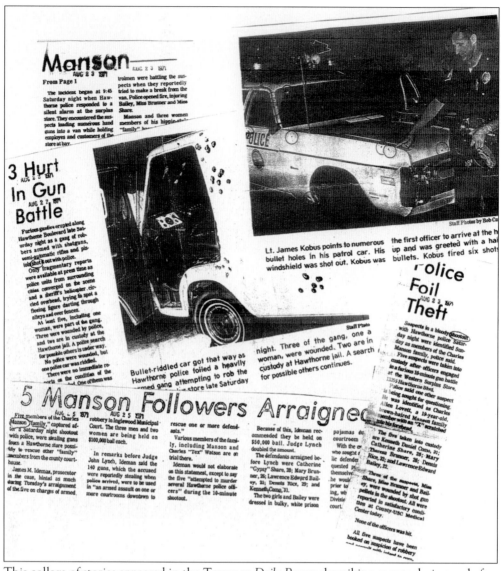

This collage of stories appeared in the Torrance *Daily Breeze* describing events during and after the most notorious episode of mayhem in Hawthorne's history. Members of the Charles Manson gang broke into the Western Surplus Store at Hawthorne Boulevard and 134th Street at 9:45 p.m. on Saturday, August 21, 1971. While they held employees at gunpoint in an attempt to steal firearms, a silent alarm was tripped, and police responded and surrounded the store. A chaotic gun battle ensued for 10 minutes after a woman in the getaway van opened fire on a police cruiser that attempted to close off a rear escape in the alley. The robbers were armed with a sawed-off shotgun, two .44 Magnum handguns, and an M-1 carbine. Three of the five gang members were hit by shotgun pellets, subdued, and hospitalized. The two others were jailed. All five were prosecuted in the arms theft attempt—their intended preamble to a wild plot. They wanted to forcibly break out of prison Charles Manson and his cult followers, who were serving life sentences for the Tate/LaBianca murders. One Hawthorne police cruiser in the furious crossfire was riddled with 109 rounds.

This photo was taken after a tornado came through town, mainly along Ramona Street, in November 1966. Damage was recorded throughout the city.

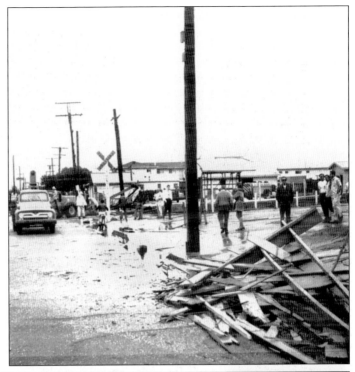

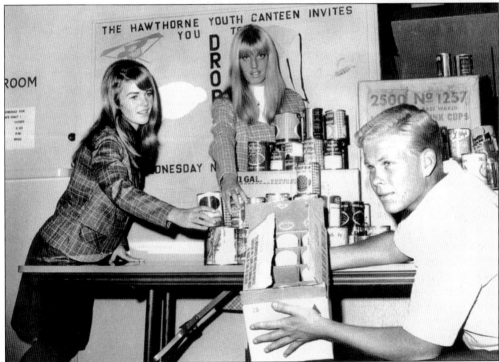

Youngsters help gather and distribute food for needy families during a mid-1960s Christmas drive. The Hawthorne Youth Canteen was one among several benevolent organizations that mobilized at Christmas time to aid children and families in need.

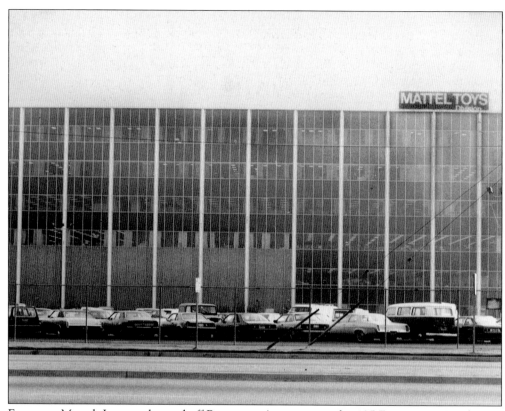

For years, Mattel, Inc. was located off Rosecrans Avenue near the 405 Freeway in Hawthorne. Mattel was founded in 1944 and made toy music boxes, Burp Guns, the Fanner 50 toy Western pistol, Chatty Cathy, Baby First Step, Thingmaker activity toys, and many, many more toys. In 1973, the Securities and Exchange Commission found the company principals guilty of fraud. Yet by 1977 a new administration had the company profitable again and operating other businesses, including Ringling Brothers and Barnum & Bailey Circus, Western Publishing, and Intellivision. The company's successful line of toys also includes the Hot Wheels line. Mattel absorbed Fisher-Price in 1993, distributed the Cabbage Patch Kids in 1995, and partnered with The Walt Disney Company, Hanna-Barbera, Nickelodeon, and other companies in the 1990s.

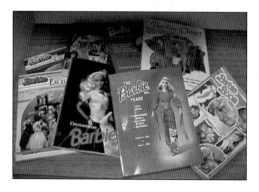

This sampling of Barbie doll books is a mere representation of the fascination surrounding—and marketing power of—Hawthorne company Mattel's enduring creation. Barbie debuted in 1959, inspired by Mattel owner Ruth Handler's daughter's fascination with cutout dolls. Barbie's boyfriend, Ken, came out in 1961. The Barbie doll led the company to the forefront of the toy industry. Mattel incorporated in 1948 in Hawthorne and remained in the city until the 1990s.

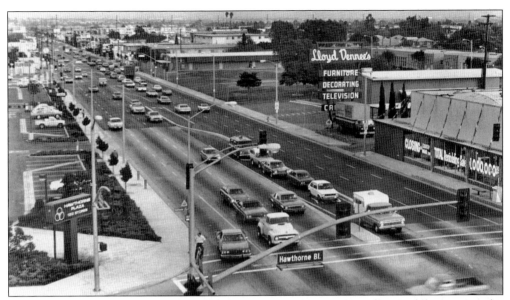

This 1976 view shows El Segundo Boulevard, looking east toward Gardena and the Los Angeles County neighborhood of Athens at the Hawthorne Boulevard intersection.

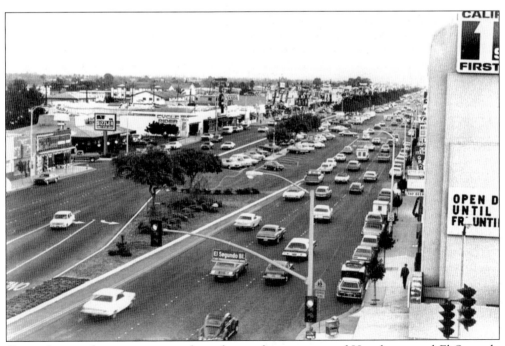

Shown here is the vantage point from the northwest corner of Hawthorne and El Segundo Boulevards, looking southeast toward Lawndale.

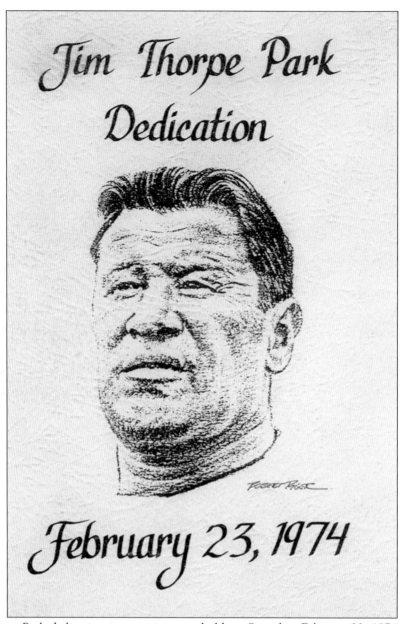

Jim Thorpe Park Dedication

February 23, 1974

Jim Thorpe Park dedication ceremonies were held on Saturday, February 23, 1974, at 139th Street and Prairie Avenue in Hawthorne. Bill Schroeder was the master of ceremonies. The guests included past Olympic winners, and mayor Joe Miller dedicated the park on behalf of the city council—Robert Reeves, Champ Clark, Jack Moore, and Greg Page—and all of the residents. Leonard Morgenthaler of Metro-Goldwyn-Mayer sang the "Star Spangled Banner" with the accompaniment of the U.S. Marine Corps Band. The invocation was co-delivered by Father Robert Gallagher and actor Jay Silverheels, the son of a Mohawk chief who had acted in dozens of movies and played Tonto in the long-running Western series *The Lone Ranger*. Comedian Jonathan Winters provided some commentary after the unveiling of the Jim Thorpe bronze plaque. Kenneth Hahn, then chairman of the Los Angeles County Board of Supervisors, issued a proclamation.

Angie Pappas and George Polous owned Holly's and several other South Bay coffee shops, including the Parasol in Torrance and Pann's in Westchester. All three of them were Art Deco coffeeshop classics.

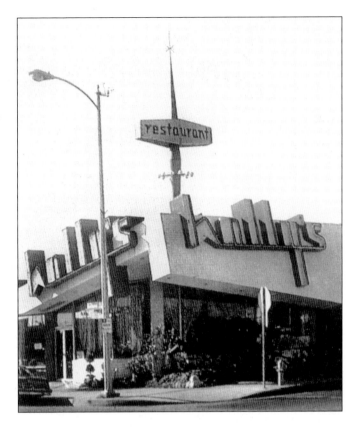

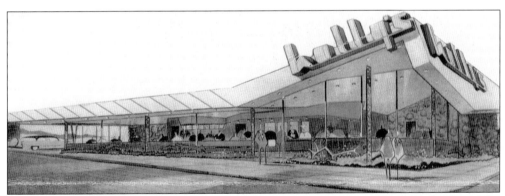

Holly's was located on the southwest corner of Hawthorne Boulevard and 137th Place. The restaurant, seen here in an artist's rendering that was reproduced on the menu, wasn't just a place of business, but a sort of extended Hawthorne family for the owners, employees, and diners. One Christmas season the habitués climbed on a flatbed truck and toured Hawthorne singing Christmas carols. That was Holly's.

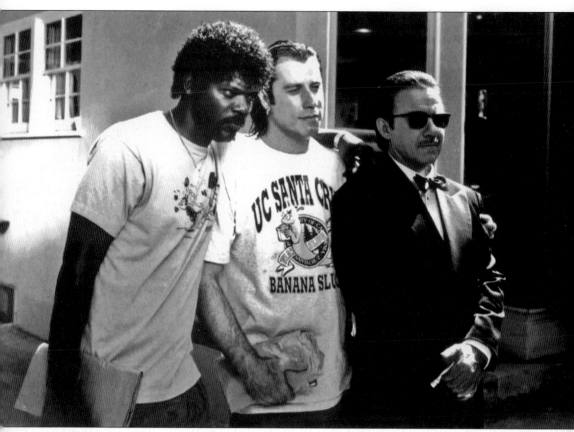

Holly's garnered new ownership and became the Hawthorne Grill in the 1990s. Located at 13763 Hawthorne Boulevard, the eatery fulfilled filmmaker and former Hawthorne resident Quentin Tarantino's vision on September 20, 1994, for "book-ending" scenes in the landmark production of *Pulp Fiction* (1994). The film starred Samuel L. Jackson, above left, and John Travolta, center, as hit men. Harvey Keitel, right, co-starred as Mr. Wolfe.

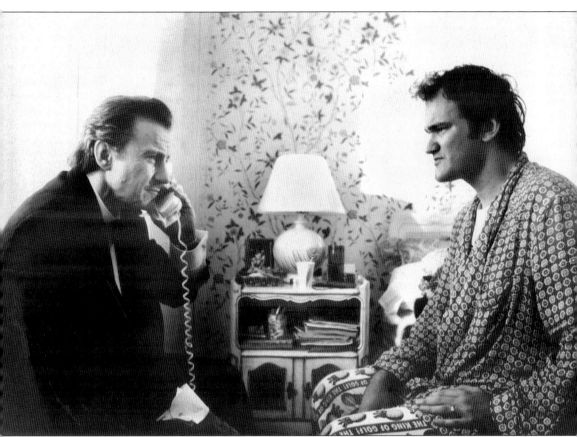

Quentin Tarantino, pictured here in a small role (with Harvey Keitel, left), won an Academy Award for co-writing the screenplay of *Pulp Fiction* with his Manhattan Beach video store (the defunct Video Archives) coworker Roger Avary. As a boy, Tarantino attended the former Hawthorne Christian School. Tarantino's other films as a writer-director include *Reservoir Dogs* (1992), *Jackie Brown* (1997), *Kill Bill: Vol. 1* (2003) and *Kill Bill: Vol. 2* (2004). *Jackie Brown*, starring Pam Grier, featured a scene between Robert De Niro and Samuel L. Jackson shot on May 2, 1997, at the old Cockatoo Lounge (4334 West Imperial Highway) in Hawthorne.

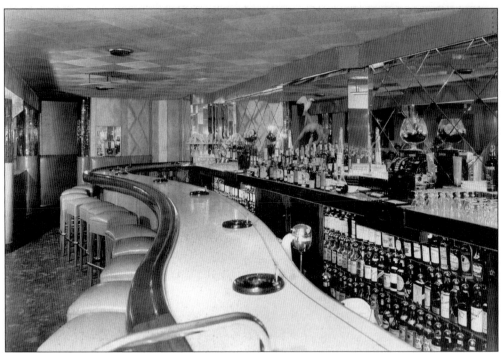

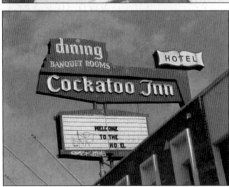

The Cockatoo Inn was one of Hawthorne's most widely known gathering spots. Located at the corner of Imperial Highway and Hawthorne Boulevard, it was a hotel, resort, watering hole, and fine-dining emporium for patrons from all walks of life. The bar (above) was one of the South Bay's most elegant.

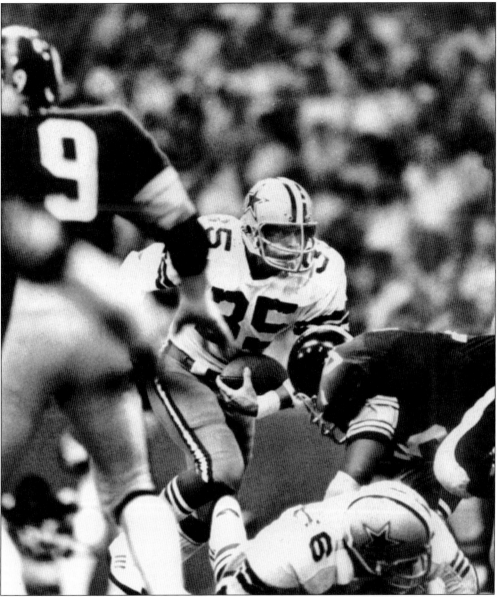

Among the football stars who honed their skills on the playing fields of Hawthorne High was Scott Laidlaw, who played six seasons (1975–1980) as a running back in the National Football League, five for the Dallas Cowboys and one for the New York Giants. Here, Laidlaw runs between Pittsburgh Steelers and future Pro Football Hall of Famers Jack Ham, left, and "Mean" Joe Greene, right, in Super Bowl XIII.

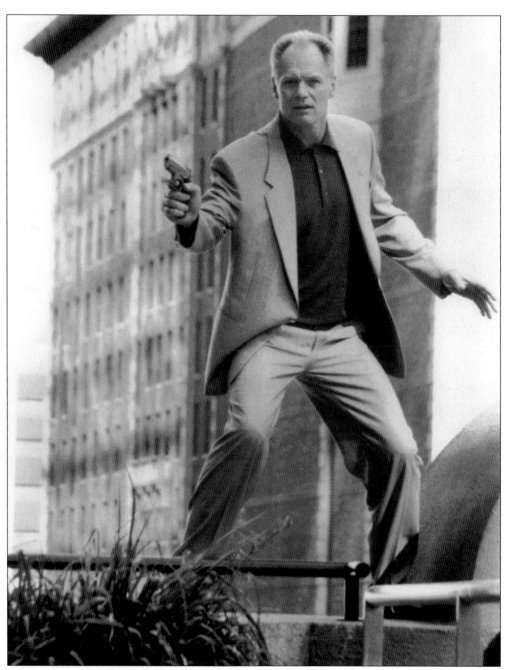

Fred Dryer was another outstanding Hawthorne-born football player who managed outstanding success in another realm of fame—performing as an actor on television. He starred as police detective sergeant Rick Hunter in the popular *Hunter* series on NBC from 1984 to 1991. A Lawndale High product, Dryer played at El Camino College and San Diego State. He was drafted in 1969 in the first round by the New York Giants. He was traded to the Los Angeles Rams for the 1972 season and became a Rams fixture at defensive end for a decade. He was named All-Pro in 1973, 1974, and 1975. Dryer is a member of the College Football Hall of Fame and holds the pro record for most safeties in a game (two).

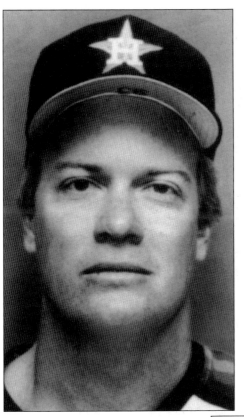

Mike Scott won the Cy Young Award as the National League's best pitcher in 1986. The Hawthorne High product went 18-10 that year for the Houston Astros, leading them to the NL Championship Series. In that series, he overwhelmed the New York Mets in games one and four, winning the first postseason victories in franchise history. Scott led the league in 1986 in earned run average (2.22), shutouts (5), strikeouts (306), and innings pitched (275). He was an All-Star in 1986 and 1987. In 1989, he led the NL in victories with 20. In a 13-year career with the Mets and Astros, Scott won 124 regular-season games and lost 108 for a .534 winning percentage.

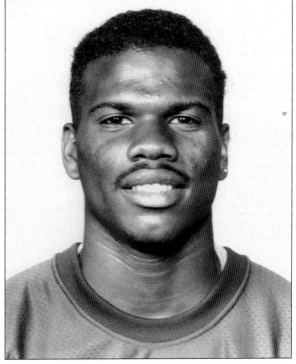

Curtis Conway, a Hawthorne High star, played for more than a decade as a wide receiver in the NFL. Conway gained more than 1,000 yards in receptions in 1995 and 1996 for the Chicago Bears and in 2001 for the San Diego Chargers. In a career that included seasons for the New York Jets and San Francisco 49ers, Conway scored more than 50 touchdowns. Like Conway, another Hawthorne High wide receiver, Travis Hannah, played his college ball at the University of Southern California, then in the NFL for the Houston Oilers.

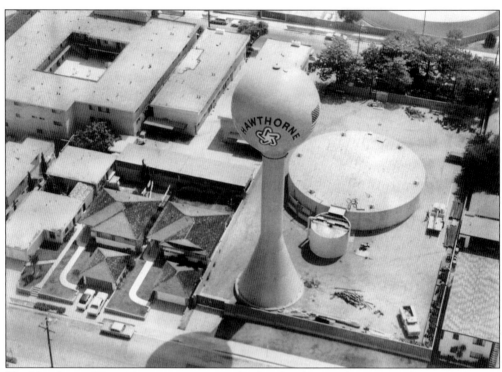

The Hawthorne Water Tower remains a city landmark. This aerial view was taken in the 1980s.

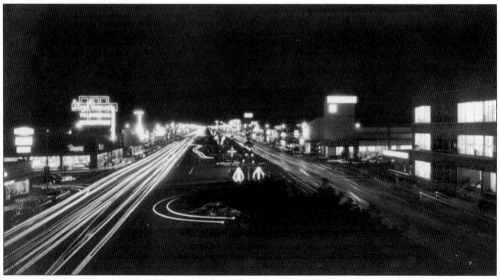

This nighttime view of Hawthorne Boulevard in the 1960s looks south from 126th Street.

BIBLIOGRAPHY

Bernard, Jami. *Quentin Tarantino: The Man and His Movies*. New York: HarperPerennial, 1995.

Cole, Ella. *Felix Peano, Sculptor: A Summary of Twenty Months of Research on an Unknown Artist*. Inglewood, California: Ella Cole, 1967.

Dennis, Jan. *A Walk Beside the Sea: A History of Manhattan Beach*. Manhattan Beach, California: Jan Dennis, 1987.

Feldmeir, Daryle. "Gorgeous Moneybags. [George Wagner]." *Minneapolis Tribune*, May 8, 1955.

Gaines, Steven. *Heroes and Villains: The True Story of the Beach Boys*. New York: New American Library, 1986.

Handler, Elliot. *The Impossible Really Is Possible: The Story of Mattel*. New York: Newcome Society in North America, 1968.

Hartman, Robert S. *History of Hawthorne*. Hawthorne, California: Hawthorne Chamber of Commerce, 1982.

Kepos, Paula, editor. *International Dictionary of Company Histories*, Vol. 7. Detroit: St. James Press, 1993.

Lurie, Rod. *Once Upon a Time in Hollywood: Moviemaking, Con Games, and Murder in Glitter City*. New York: Pantheon Books, 1995.

McCawley, William. *The First Angelinos, the Gabrielino Indians of Los Angeles*. Banning, California: Malki Museum Press/Ballena Press, 1996.

McGaffey, Ernest, and George Steele, Fred C. Justice and Leo O. Davies. *Hawthorne Police and Fire Annual 1930*. Hawthorne, Calif.: Hawthorne Police and Fire Relief Association, 1930.

Osborne, James. *Some Images of Lawndale's Past*. Lawndale, Calif.: James Osborne, 2004.

Patton, Gregory, and Peter Monge and Janet Fulk. *Policing Hawthorne*. South Pasadena, California: Keystone Communications, 2000.

Roberts, Jerry. "Hot Property: South Bay's Tarantino Hits Pay-dirt With Scripts." Torrance, California, *Daily Breeze* October 21, 1992: D1.

Robertson, Douglas T. *Hawthorne and the Centinela Valley: A Portrait of a Memory*. Fresno, California: Portraits, 1984 and 1993.

Scheerer, Lorietta Louise. *The History of the Sausal Redondo Rancho*. Los Angeles: University of Southern California, Master's Thesis, 1938.

Shevey, Sandra. *The Marilyn Scandal: Her True Life Revealed by Those Who knew Her*. New York: William Morrow and Co. Inc., 1987.

Slagle, Steve. "Gorgeous George." The Professional Wrestling Hall of Fame as presented by *The Ring Chronicle*, http://www.wrestlingmuseum.com, 2000.

Spoto, Donald. *Marilyn Monroe: The Biography*. New York: HarperCollins, Publishers, 1993.

Tatum, Donn Benjamin Jr. *The Rancho Sausal Redondo*. Los Angeles: University of Southern California, Master's Thesis, 1968.

Wheeler, Robert W. *Jim Thorpe: World's Greatest Athlete*. Norman: University of Oklahoma Press, 1978.

Wiedel, Ann Elizabeth. *The Centinela Valley—A Tale of Two Ranchos*. Long Beach, California: California State University, Long Beach, Master's Thesis, 1980.